DAME
Laura Knight

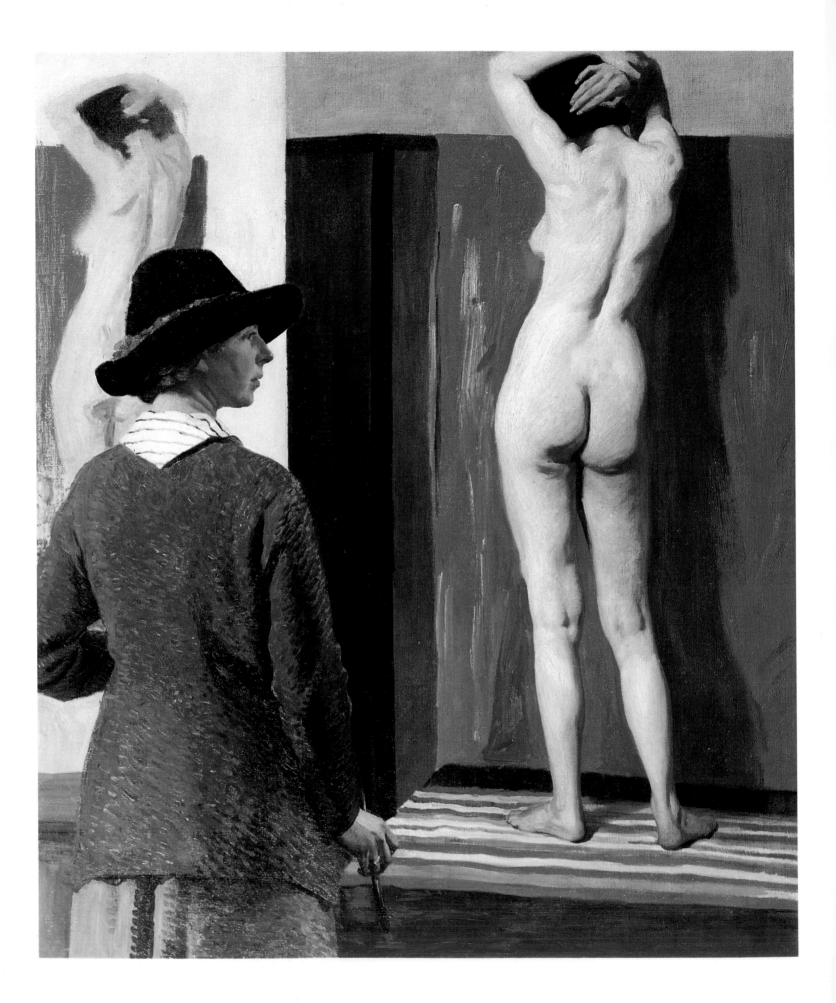

DAME
Laura Knight

CAROLINE FOX

PHAIDON · OXFORD

For my parents

Phaidon Press Limited, Littlegate House, St Ebbe's Street,
Oxford OX1 1SQ

First published 1988
© Phaidon Press Limited 1988

British Library Cataloguing in Publication Data

Fox, Caroline, *1947–*
 Dame Laura Knight.
 1. Knight, *Dame* Laura —— Criticism and interpretation
 I. Title
 759.2 ND497.K5

ISBN 0–7148–2447–X

Printed in Great Britain

Frontispiece. *Self-Portrait with Nude*. 1913. Oil on canvas, 152.4 × 127.6cm (60 × 50¼in). London, National Portrait Gallery

Acknowledgements

I am particularly grateful to my friend and colleague Jane Baker, Keeper of Fine Art at the Royal Albert Memorial Museum, Exeter, for all her support and encouragement throughout the research and writing of this book.

I would like to thank the following for being so generous with their time, help and hospitality: Mrs P. Barber, Miss Gwen Ffrangçon–Davies, Lady Monteath, Mrs C. Pike, Mrs Rosenberg and Mr R. Shuttlewood.

Janet Green and Susan Kent of Sotheby's have been very generous in allowing me a free run of their records on several occasions; the following have also been extremely helpful: Francis Farmar of Christie's, Irving Grose of The Belgrave Gallery, C. J. Day of Eastbourne Fine Art, Gavin Graham of The Gavin Graham Gallery, Amanda Kavanagh of Richard Green Fine Paintings, Manya Igel of Manya Igel Fine Art, David Messum and Laura Wortley of David Messum Fine Paintings, James Crook of Phillip's and Alan and Mary Hobart of Pyms Gallery.

I am most grateful to the many curators of the various municipal museums and galleries who have kindly supplied information and photographs.

The staff of the Nottingham Record Office were extremely helpful during my visit to Nottingham and I would like to thank my friend Helen James, Librarian at the Exeter College of Art & Design, for all her help and support in obtaining books and articles.

Finally, I would like to thank Diana Davies for being such a helpful and encouraging editor, and Bruce Sinclair for producing photographs at the last minute.

Caroline Fox September 1987

Contents

1 *Early Years in Nottingham and Staithes* 7

2 *Cornwall* 25

3 *London: The Ballet and the Theatre* 47

4 *London: The Circus* 65

5 *London: The Gypsies and the Malvern Festival* 85

6 *The Second World War* 101

7 *Her Last Years* 115

Bibliography 125

Photographic Acknowledgements 125

List of Plates 126

Index 127

1. *Staithes, Yorkshire*. 1900. Oil on canvas, 75 × 62.2cm (29½ × 24½in). Chamberlain Fine Art

1
Early Years in Nottingham and Staithes

'I had loved pencil and paper to be thrust through the "bars" of my cradle.'

Laura Knight has become almost as well known for the fascinating story of her life as for the work that she did. Her two autobiographies, *Oil Paint and Grease Paint* (1936) and *The Magic of a Line* (1965), have done much to bring this to the wider public notice and they reveal her early life as of prime significance to her career as an artist. On the one hand, financial hardship and family illness forced her to grow up faster than is usual in normal family life, and may have helped foster the tenacity she needed in order to succeed as an artist. On the other, the wealth of love and care she received from her mother and grandmother gave her the best possible start in life. In fact, it was probably her mother's early encouragement of her art, and ambitions for her success, that sowed the seed which was to flower so richly throughout her life.

She was born in Long Eaton, Derbyshire, in 1877, the third in a family of girls. Her father, Charles Johnson, had left home shortly before her birth and died not long after. On the departure of her husband, Laura's mother, Charlotte, had taken the girls to live in Nottingham with her own mother ('Big Grandma'), brother and grandmother ('Little Grandma'). The family was a close-knit one and provided the girls with a warm and yet stimulating environment in which to grow up.

The family income derived from a lace-machine factory which belonged to Big Grandma and was run by Uncle Arthur Peter. Unfortunately, Laura's early years coincided with the decline in the Nottingham lace industry which was becoming centred in France and her family became steadily poorer and had to move to increasingly smaller houses. Laura's two sisters, Nellie and Sis, were sent to school at Brincliffe, one of the best girls' schools in the Midlands, where Charlotte taught painting and drawing in return for their education. Charlotte also had to give private tuition to provide housekeeping money for herself and the girls. Laura was affected by these financial difficulties in ways which went very deep and she remembered having to wear her sisters' cast-off clothes and having to spend pocket money on such essential items as a pair of shoes. Later, as they became poorer, Charlotte used to make the girls' shoes herself. These home-made creations were greeted with howls of mirth by the children's school-fellows.

Nevertheless, Laura had many happy memories of her childhood, too. She was fascinated to listen to her elders discussing politics and developed very socialist views as a result. The adults also found time to pursue hobbies

and outside interests, which was undoubtedly enriching for the family as a whole. Charlotte was able to attend evening lectures and play the piano as well as teaching art, while Uncle Arthur Peter, besides being a keen gardener, collected inexpensive antiques. Books were in plentiful supply in the household and Laura was encouraged to copy drawings by such noted nineteenth-century illustrators as Keene, du Maurier and Tenniel from those in her uncle's collection.

There were also treats. Uncle Arthur Peter's friends used to bring sweets and books for the girls and there were visits to the local fair and even occasional holidays to Derbyshire and once to Scotland. The famous Nottingham Fair, known as the Goose Fair, was a lively and colourful event which made a strong impact on Laura: it contained all the ingredients of the subject-matter to become so important to her in later life – that of fairs, circuses and the gypsies. The Goose Fair was held annually in the central market-place in Nottingham until the 1920s when it was relegated to the 'Forest' about a mile away. It was the largest fair in England and its origins went way back beyond the reign of Edward I.

Charlotte was a good mother and when not teaching or making the girls' clothes encouraged their efforts with pencil or brush. She was particularly anxious to convey to them her own great love of art and was overjoyed that Laura, especially, was so quick to respond. From an early age, Laura could be happily left with pencil and paper for hours on end. As an artist and teacher herself, Charlotte was able to provide professional help and to give every possible encouragement.

Eventually, however, the strains of supporting and looking after her family following the earlier stress of an unhappy marriage, proved too much for Charlotte and she suffered a severe breakdown. Fortunately, her Aunt West, who ran a flourishing lace-business at St Quentin, near Amiens, came to the rescue and financed a visit to Paris. Charlotte returned home a few months later, rested, fully recovered and enthusiastic about the work of the French Impressionists.

Her own unhappy marriage made her particularly anxious that the girls should have careers with which to support themselves and Nellie and Sis were taken away from school early in order to learn to become board-school teachers. This involved them in a rigorous programme of daytime teaching and evening study leaving Laura very much on her own. She had by then followed her sisters to Brincliffe where her mother continued to teach drawing and painting in return for her education.

The year 1889 was an important one for Laura. As the most artistically inclined of the three girls, she was sent to France to stay with her Great Aunt West. It was intended that she should later study art in a Parisian atelier. At first, however, she was sent as a boarder to a local school where, as one of only two English girls, she became the target for bullying by girls and teachers alike. Her only relief was in her friendship with the other English girl. Her unhappiness was greatly increased by the fact that shortly after her arrival she heard that her sister Nell had died due to a very bad attack of influenza. As the year progressed, Laura's natural toughness emerged. In fact, she adapted so well to her new environment that when her grandmother became ill and the family business collapsed, she was reluctant to return to England. She was naturally disappointed at losing the opportunity of studying in Paris. But she had no time to brood on this for the very evening of her return to England, she was enrolled in the Nottingham School of Art. She was then only 13 and therefore was probably one of the youngest pupils they had ever had.

Laura was fortunate in attending the Nottingham School of Art when Wilson Foster was in charge of the life-class. He was a particularly able teacher and more open in his outlook than many of his colleagues, having studied in Paris and Antwerp and also visited the British art colonies at Newlyn and St Ives. He believed that

students should learn to draw and paint with absolute attention to detail but that they should also be allowed to develop in their own way. Possibly as a result of his influence, the School of Art had a high reputation at the South Kensington Schools, where work from art schools all over the country was sent in annually for judging and awards.

One of the most promising students at the Nottingham School was Harold Knight, then just 17, who was destined to play an important part in Laura's future life. Laura soon decided that she would learn most by copying Harold's technique and used to sit as near to him as she could in order to watch his every move.

No sooner was Laura settled at the School of Art when further tragedy hit the family. After a serious collapse, Charlotte was found to be suffering from cancer and was given two years to live. At the age of 14, Laura had to become the family breadwinner and take on her mother's teaching posts for which she sometimes had to pretend she was 20. When not teaching, she had to take turns with her grandmother and sister at nursing Charlotte, who was in extreme pain. Sis, who was not as strong as Laura, eventually became ill and had to be sent to the country to recuperate.

Laura found some relief from this situation in her growing friendship with Harold Knight. The two had begun to see each other fairly frequently and Harold took her to his home to meet his family. He also used to visit Charlotte, who became very fond of him and did her very best to encourage the relationship. A portrait of Laura, painted by Harold at this time, shows her to be a robust, solid-looking girl with rosy cheeks and long, fairish hair. Although not pretty, she had a pleasant face with strong features.

After her mother's death, Laura continued to live with her grandmother; her uncle had already moved to St Quentin to work with Great Aunt West. Big Grandma became very interested in Laura's paintings and gave her every encouragement and the following months were happy ones for Laura. However, when Big Grandma too died, at the end of that year, Laura and Sis were left completely on their own. They had to live on a small sum sent to them every month by their uncle, and on Laura's earnings as a teacher. Although this covered the rent of their room, it did not allow for much else, and for months on end the girls used to live on porridge, bread and butter. Saturdays were the highlight of the week when Harold Knight arrived bearing unheard of luxuries such as cakes, pies and sausages for their tea!

Laura's work was not progressing as before. During her first year at the School of Art, the men and women had shared a studio, but afterwards they were separated, the men, who were considered the more serious students, receiving the most attention. Women were further disadvantaged by not being permitted to draw from life models and having to use plaster casts instead. Laura felt that this created a dead atmosphere in her work which took many years to overcome, although some drawings made during these early years, such as the *Self-Portrait* (Pl. 2) and *Man in a Top Hat* (Pl. 3), appear far from dead and show a high degree of sensitivity and technical skill for one so young. An equally competent drawing of a girl from about the same period (Pl. 4) was later bought by Foster himself. Laura's proficiency in drawing was recognized and in the National Competition at South Kensington she was awarded the Princess of Wales Scholarship of £20 a year for two years because she had won more awards than any other woman in Britain. One of these awards, a gold medal, she sold for £5 10s in order to pay for living expenses.

Shortly afterwards Laura and Harold left the School of Art, feeling they had learnt all they could there. Harold was offered a mastership, which he declined since he felt it would have held up his development as a creative artist, although it would have guaranteed a steady income. Instead, he spent the following year in Nottingham saving up to go to Paris on a British Institute Travelling Scholarship.

An exhibition which particularly affected Laura at this time was the 'Special Exhibition of Pictures by

2. *Self-Portrait*. *c.*1892–4. Black chalk, 39 × 29cm (15¼ × 11½in). Sotheby's

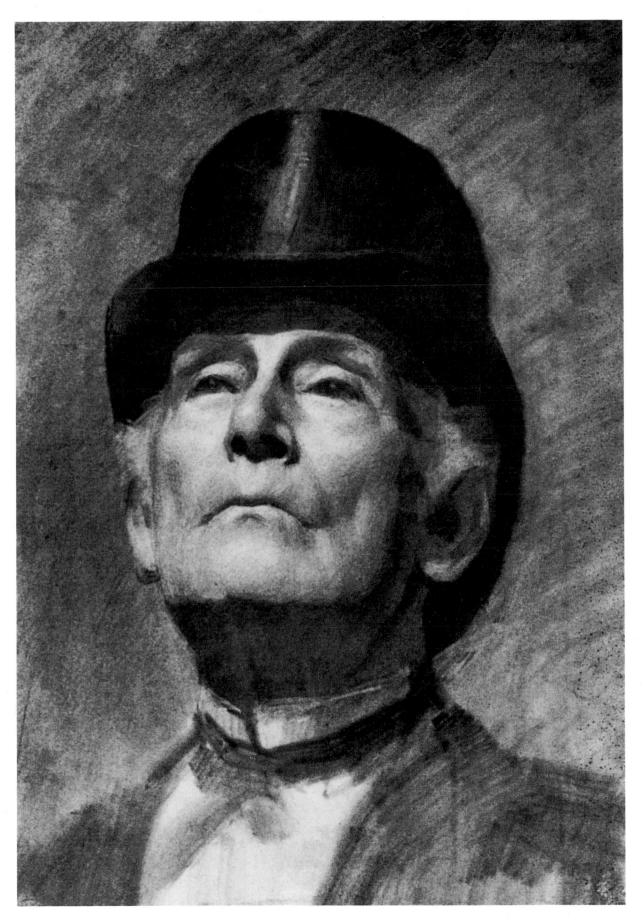

3. *Man in a Top Hat*. 1892–6. Charcoal on paper, 46.4 × 31.8cm (18¼ × 12½in). Nottingham Castle Museum

Cornish Painters' held at the Nottingham Castle Museum in 1894. This included works by the Newlyn, St Ives and Falmouth artists. Laura was especially drawn to the work of the Newlyn artists: 'my favourite picture was Frank Bramley's *Hopeless Dawn*. Tears came into my eyes I thought it so wonderful. There was also a little grey picture of Newlyn Bridge by Stanhope Forbes. I did not know anyone could paint like that.'

Laura and Sis found rooms underneath the Castle in Nottingham where there was also space for a studio. For the first time in her life, Laura started trying to plan her subject-matter. She found this very difficult, for the School of Art, although giving a very good grounding in drawing and painting from life or plaster casts, had taught nothing about composition. Laura felt attracted by the market-place but feared the cold and the jostling crowds which would have gathered to watch her draw, and instead began to paint subjects based on the local slum children who were the cheapest models she could find. They would sit for sixpence and a mug of cocoa and as much bread and butter as they could eat! Perhaps it was her recent success at South Kensington which encouraged Laura to send her first painting of these children to the Royal Academy and, perhaps not surprisingly, it was rejected. Laura also enjoyed painting portraits and used her uncle as a model when he was over on a visit from France. The result was greatly admired by a local collector who offered her £250 a year to paint portraits for him. Fortunately for her future development, perhaps, he was unable to fulfil this offer because of a financial crisis.

Harold returned from Paris the following year, worn out and in rags because his money had run out sooner than expected. His paintings, however, had not greatly changed as a result of the visit and it would appear that he was probably more bewildered than anything else by the work he had seen there. His feelings about Laura had not changed either and they settled down to be just as good friends as before. After some months, Sis became ill and Great Aunt West, hearing of this, came over to England and decided that they all needed a holiday. She took Laura, Sis and Harold to the village of Staithes in Yorkshire, chosen on the recommendation of one of the teachers at the School of Art, William Barrett, who had told them that there was nowhere quite like it on all the coast for painting.

The fishing-village of Staithes had been an artists' colony since the 1880s, attracting artists from northern and Midland towns, who came to paint the harsh, rugged landscape (Pl. 1). Life for the villagers was very hard, dependent as they were on fishing in the North Sea, and many fishermen lost their lives each year. Laura responded very deeply to the wild, austere way of life which provided such a contrast to city life:

As long as I can remember I had wanted to run wild in a broader life, away from factories, miles from houses in rows, dressed-up shops and the gentility of town where no one knows what their neighbour enjoys or endures. Here in Staithes we share each others' joys and sorrows.

After the holiday, Laura and Sis returned to Nottingham for a few months, only to go back and settle in Staithes the following year. Harold was already living there with two other artists, and beginning to support himself through selling his work. Laura and Sis found a small cottage with a low rent which they were able to furnish from sales. They were soon accepted into village life and became involved in its ups and down, its festivities and its terrible tragedies.

The years spent in Staithes were crucial ones for the young Laura in her struggle to find her own way of expression. Harold refused to help her, possibly because he felt unable to do so or feared that their work would become too similar, and Laura floundered about trying to copy works by the other artists in Staithes. She was eventually rescued by Charles Mackie, a Scottish artist whom she met at a local hockey match, and he came to act as her teacher. He used to walk over to her studio once a week and encouraged her to stop trying to imitate other artists' methods and to paint what she actually saw. He taught her to observe her subject and gave her useful information

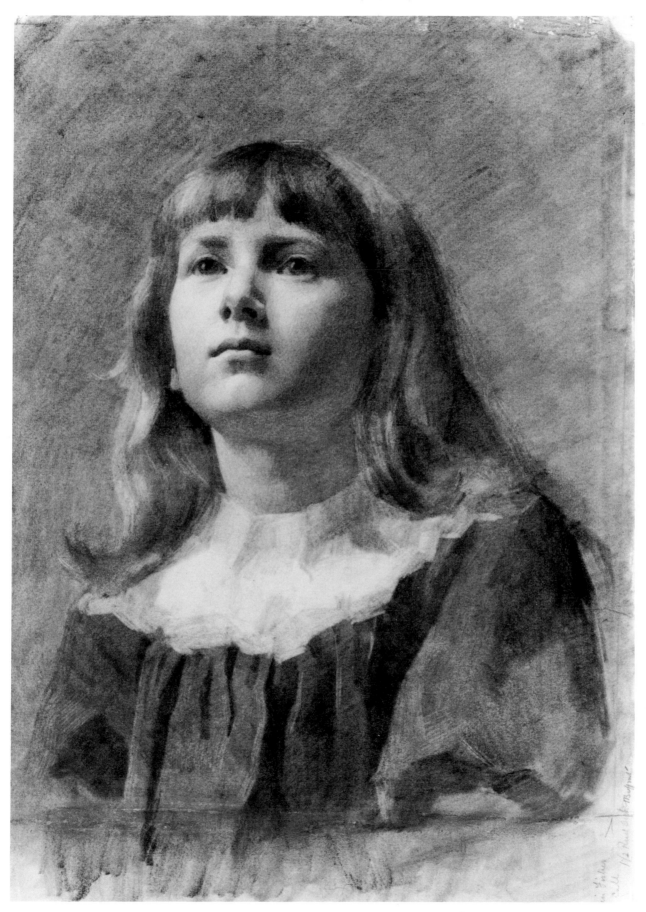

4. *Girl's Head. c.*1891. Charcoal and chalk, 56.5 × 39.4cm (22¼ × 15½in). Leicester Museums and Art Galleries

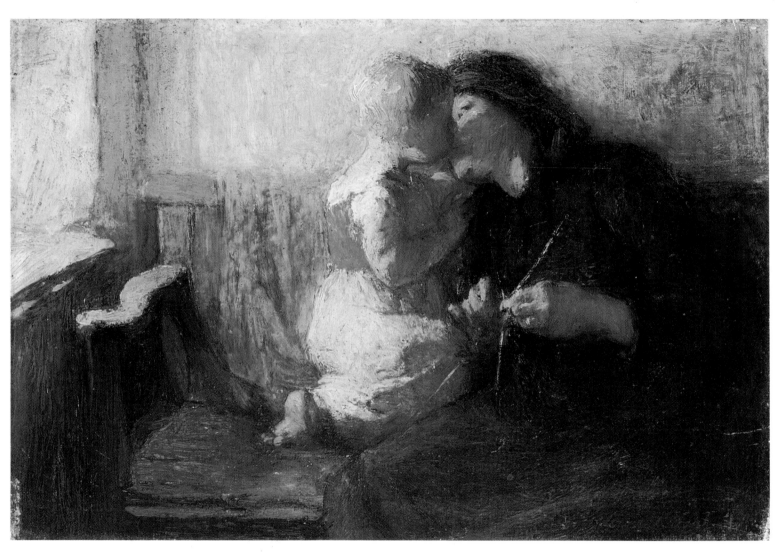

5. *Mother and Child*. 1901. Oil on canvas, 17.7 × 25.4cm (7 × 10in). Collection Gavin Graham

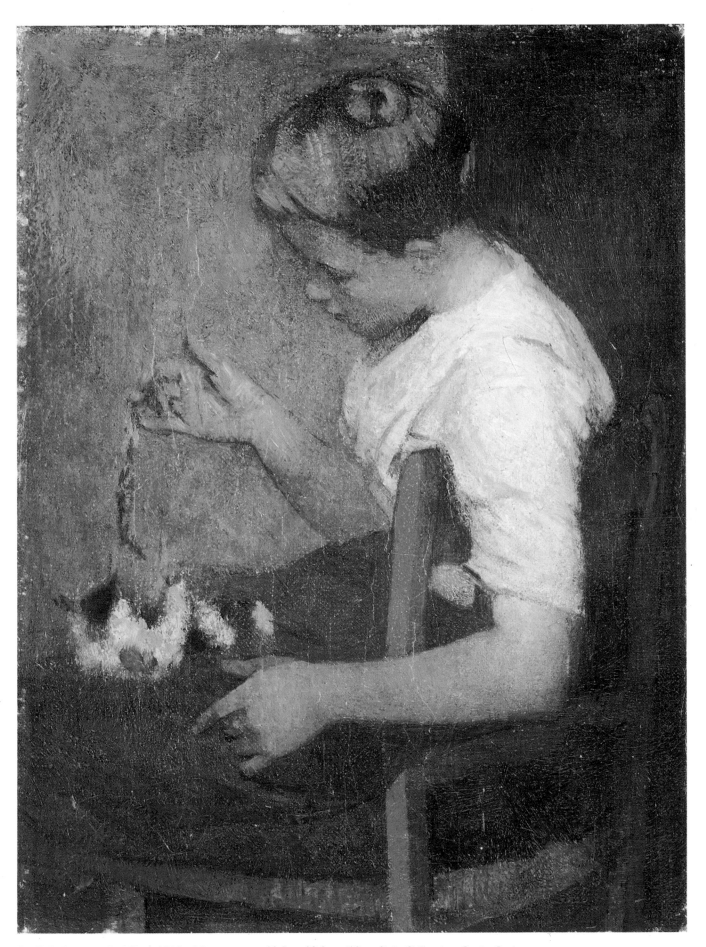

6. *Girl playing with a Cat. c.*1903. Oil on canvas, 30.5 × 22.8cm (12 × 9in). Collection Gavin Graham

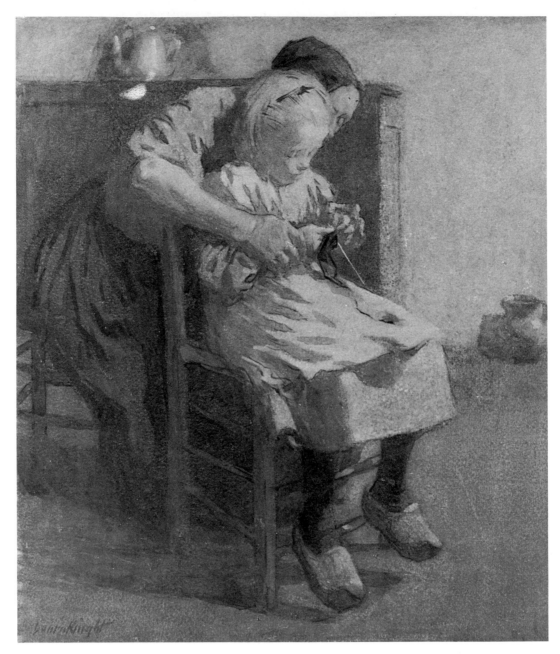

7. *The Knitting Lesson*. Watercolour, 37 × 31.7cm (14¼ × 12½in). Preston, Harris Museum and Art Gallery

about complementary colours. Laura stated that she never took up her brush after that without being grateful to him for his support.

Her work of the period shows that she had taken Mackie's advice and begun to observe for herself. As a result it has greater depth. She developed a very real understanding of children and their movements as is shown in *The Knitting Lesson* (Pl. 7) and *The Elder Sister* (Pl. 8), which are painted with tenderness and sensitivity. *Mother and Child* (Pl. 5) and *Girl playing with a Cat* (Pl. 6) are further examples of her soft technique at this time.

The work which interested and influenced Laura most during this period was undoubtedly that of the '*plein air*' realism of the Newlyn, Glasgow and Staithes painters, and of George Clausen, Edward Stott and Henry La

8. *The Elder Sister. c.*1907. Oil on canvas, 32.5 × 25cm (12¾ × 9⅞in). Rochdale Art Gallery

Thangue. These artists were rebelling against the work of the mid-nineteenth-century academic painters such as Frederic Leighton, Edward Poynter and Lawrence Alma Tadema, and also disliked the historicism and sentimentality of the Pre-Raphaelites and their followers. They belonged to a late nineteenth-century movement which saw the formation of art colonies in rural areas throughout Europe. Following in the footsteps of some of the French Barbizon and Dutch Hague School painters of the earlier part of the century, they felt a strong mission to depict the everyday life of the rural poor. Stylistically, many of the artists were influenced by a now little-known French painter, Bastien-Lepage, who had devoted his short life to depicting the poor in the village of his birth. He believed in absolute realism, painting *en plein air* or on the spot, and achieving harmony of tone by using a low-key range of

colour. In Britain, works by the followers of Bastien-Lepage adorned the walls of the Royal Academy from the 1880s and several were purchased for the nation.

Many of the Newlyn and Glasgow artists were members of the New English Art Club which was founded in 1886 as an alternative exhibiting body to the Royal Academy. Its achievements have been summed up by its biographer, Alfred Thornton: 'Into a hothouse of sentimentality in the late 'eighties it blew again the fresh breath of the open air, of the vitality of the thing seen, of reality faced and its beauty sought out.' Within a few years, the *plein-air* realists were to become accepted within the establishment and the New English Art Club was to be dominated by more 'advanced' artists such as Sickert and Wilson Steer.

In 1903 Laura had her first painting, entitled *Mother and Child*, hung at the Royal Academy. To her surprise and pleasure, it was bought by the artist Edward Stott, for £20. Another painting of a family was exhibited at the Royal Academy in 1906, entitled *Dressing the Children* (Pl. 9). It shows an intimate domestic scene with a peasant woman dressing her children and in both subject-matter and style is close to the work of the Staithes and Newlyn painters. Her painting of the return of the local fishing fleet (Pl. 13) gives a grim picture of the harsh life style experienced by the Staithes fishermen and their families. The depressing mood is heightened by her use of very thick paint and the lone woman in the foreground completes the sense of isolation. *The Mirror* (Pl. 10) is painted with this same very thick use of paint or impasto.

Laura painted many watercolours while in Staithes, some of which demonstrate a surprising freedom. Subjects range from old women in interiors performing simple household tasks such as knitting, peeling potatoes (Pl. 11) and plucking geese (Pl. 12) to children playing on the beach, where many days were spent drawing and painting during the summers. Most of these works show careful observation and understanding. As Laura observed in her autobiography:

> It was [at Staithes] that I found myself and what I might do. The life and the place were what I yearned for – the freedom, the austerity, the savagery and the wildness. I loved it passionately, overwhelmingly, I loved the cold and the northerly storms when no covering would protect you. I loved the strange race of people who lived there . . .

In 1903 Harold received two portrait commissions from a patron in a nearby village and he and Laura decided to marry on the strength of the payment. The simple ceremony took place in the old church near Staithes and Laura's uncle came over from France to give her away. The honeymoon was spent in London, visiting exhibitions and, in particular, an exhibition of Dutch paintings at the Guildhall. This may well have encouraged them to visit Holland the following year, where they went in company with one of the Staithes artists, Harry Hopwood.

The Knights made three visits to Holland, once spending as long as a year there when the purchase of Harold's painting *A Cup of Tea* for the Art Gallery in Brisbane in 1905 made them feel unexpectedly rich. They divided their time between painting the peasants on their farms while staying in the artists' colony of Laren, and studying works by the Old Masters in Amsterdam. They particularly admired Rembrandt, Vermeer and Frans Hals and used to study and analyse their paintings and try out different techniques. Although this method appealed to Harold, Laura soon learnt that she preferred to work spontaneously, and two landscapes painted in Holland, *In the Fields* (Pl. 14) and *A Cornfield in Holland* (Pl. 15), show her relaxed handling of paint at this period.

In early 1906 Laura and Harold visited London in order to take their work around the Bond Street galleries.

9. *Dressing the Children*. 1906. Oil on canvas, 101.6 × 140.3cm (40½ × 55¼in). Hull, Ferens Art Gallery

10. *The Mirror. c.*1900. Oil on canvas, 76 × 63.7cm (29¾ × 25⅛in). Bolton Museum and Art Gallery

11. *Peeling Potatoes*. 1900. Watercolour, 24.4 × 35.5cm (9⅝ × 14in). Nottingham Castle Museum

12. *Plucking the Goose. c.*1900. Watercolour, 26 × 32.2cm (10¼ × 12¾in). Nottingham Castle Museum

13. *The Fishing Fleet. c.*1900. Oil on canvas, 122.3 × 81.5cm (48 × 33in). Bolton Museum and Art Gallery

14. *In the Fields.* c.1904. Watercolour on paper, 19 × 22.9cm (7½ × 9in). Private Collection

15. *A Cornfield in Holland.* 1904. Pencil and watercolour on board, 25.3 × 35.6cm (10 × 14in). Newcastle upon Tyne, Laing Art Gallery

Many of the dealers were fairly discouraging but they were well received by Ernest Brown who had recently joined the Phillips brothers at the Leicester Gallery. He was the first gallery owner to give them encouragement and was to become their main London dealer for many years. Exhibitions of their Dutch paintings were held at the Leicester Gallery in 1906 and 1907. Laura recorded that these were a success and that Ernest Brown was very pleased with their work. (They exhibited there again in 1912 and Laura exhibited there on her own in 1918, 1920 [The Russian Ballet], 1926 [Etchings and Drawings], 1928 [shared exhibition with Mark Gertler] and in 1934 and 1939.)

When the Knights returned to Staithes after their final visit to Holland in 1907, they felt restless and dissatisfied. They had never really been able to get used to the terrible losses at sea, and had been considering a move to Cornwall for some time. Encouraged not only by Laura's admiration for the work of the Newlyn School artists but also by reports of a more temperate climate and longer daylight hours, they finally decided to move to Newlyn later that year.

2
Cornwall

'At the time the very bright of life beamed on us. We had never known the joys of youth before. We danced, played games and lived half the night as well as working hard all day.'

It was during the ten years spent in Cornwall (1907–18) that Laura's style reached maturity. After the struggles and hardships endured in Staithes and Holland, the more relaxed atmosphere of Newlyn provided a sympathetic background within which she could develop. Inspired by the beauty and light of West Cornwall, encouraged by the support of fellow artists, and for the first time enjoying an active social life, Laura was able to live every moment to the full. Her art blossomed, showing a greater awareness of light, the use of bright colour and freer, more vigorous brushwork.

The fishing-village of Newlyn had attracted artists since the late nineteenth century. It was conveniently situated within a mile of Penzance and the railway, and in the words of one of its leading artists, Stanhope Forbes, 'every corner was a picture, the people seemed to fall naturally into place and harmonise with their surroundings'. Inexpensive accommodation was readily available and artists quickly converted fishlofts into studios. The unique quality of the light, peculiar to this part of Cornwall, and possibly the result of its position as a peninsula, has always been a major factor in drawing artists to the area. But above all, the appeal of West Cornwall is a romantic and mysterious one, as Stanhope Forbes was the first to admit:

> What lodestone of artistic metal the place contains, I know not, but its effects were strongly felt in the studios of Paris and Antwerp, particularly by a number of young English painters staying there, who just about then by some impulse seemed drawn towards this corner of their native land.

Laura, too, felt the mysterious appeal of that part of Cornwall and that 'neither time nor the vulgar would conquer its indubitable spirit'.

By 1907, the heyday of the first generation of Newlyn artists was over, although several of them still remained in the village, including Stanhope Forbes and his wife, Elizabeth Armstrong, Norman Garstin, T. C. Gotch and Walter Langley. The Forbes had founded a School of Painting in 1899 which attracted a whole new group of artists to Cornwall and formed the focus for both artistic and social activity. Many of the students worked very hard but they also found time to enjoy the dances, parties, picnics and concerts of which there was an abundance in Newlyn during these pre-war years.

Laura threw herself into this life with tremendous gusto almost as if she was reliving a youth she had never had:

Student life in surroundings such as we had never dreamed of; a carefree life of sunlit pleasure and leisurely study. I felt old and experienced with these youngsters who really knew so much more than I of fun and social graces.

Her wild antics at a party in Newlyn were described by the future writer, Winifred Tennyson Jesse: '. . . When nothing was doing little Mrs Knight and a few others would join hands and swirl round and round, her hair streaming and ragged skirts a-whirl.'

It was at a party given by the Forbes that Laura first met Dod Shaw, who later married Ernest Procter and became a lifelong friend. Shortly afterwards she met Alfred Munnings (see Pl. 17), whose 'overwhelming vitality' was always to attract her. She admitted that she could not take her eyes off him at this time: 'he was the stable, the artist, the poet, the very land itself!' Munnings in his turn was equally drawn to Laura. He wrote in his autobiography:

Here was a great artist who never ceased working. She possessed the energy of six; the studies for her larger pictures were wonderful. It was through her that I used china-clay canvasses. Laura Knight could paint anything be it a small water-colour or a nine-foot canvas. Seeing is believing.

Munnings was the chief organizer of the Newlyn artists' hectic social life where no congenial gathering was regarded as complete without him. Small wonder that the introverted Harold felt left out and was more than a little annoyed when Munnings arrived one day to share their lodgings. But although Laura and Munnings were to remain good friends throughout their lives, there was never any question of this being more than a platonic friendship.

A warm friendship also grew up with the landscape artist Lamorna Birch and his family and both Harold and Laura spent many happy days picnicking on the rocks at Lamorna where Mouse (Mrs Lamorna Birch) and the two girls were painted by them on several occasions. Summer holidays were sometimes spent camping at Dozmare Pool on Bodmin Moor with fellow-artist couples, Harold and 'Gert' Harvey and Charles and Ella Naper. Both Gert and Ella modelled for Laura on many occasions. The Knights also became friendly with the legendary Bernard Walke, vicar of the neighbouring village of St Hilary and a great lover of the arts. He commissioned several of the Newlyn artists to decorate his church at St Hilary and was himself a playwright; one of his plays, *Bethlehem*, was broadcast annually by the BBC throughout the 1930s.

It was in this warm and friendly atmosphere that Laura's work developed and flourished. She continued to paint children as before and admitted to passing from 'Dutch influences, through a Joshua Reynolds period of amber colouring and varnish glazes into direct painting'. Two works of 1908 were accepted by the Royal Academy: *Chrysanthemums* and *The Party*. The latter, depicting a children's party, was later destroyed. Some of her more characteristic works of these early years were painted in the studio from large studies made out of doors. One of the early Newlyn artists, Norman Garstin, described the contrast between the work of his generation and Laura's paintings:

The Newlyn Group has always had the reputation of seeing through the grey fog that legend attributes to Cornwall. Whether this is so or not, the effect upon the Knights has been the exact opposite for with their

16. *The Beach*. 1908. Oil on canvas, 127.7 × 153cm (50¼ × 60¼in). Newcastle upon Tyne, Laing Art Gallery

advent, there came over their work an utter change in both their outlook and method: they at once plunged into a riot of brilliant sunshine of opulent colour and of sensuous gaiety.

The Beach (Pl. 16), one of Laura's most important Newlyn works, heralds a new era in her style and is in many ways a transitional work between the extremely colourful paintings of the following years and the less flamboyant paintings of the Staithes period. Although painted in bright colour, *The Beach* has a restricted palette, concentrating on blue, yellow, brown, red and pale pink. It may possibly owe its high horizon line to Stanhope Forbes' *Fish Sale on a Cornish Beach* of 1885 (Pl. 18). Here the resemblance ends for instead of painstakingly recording the scene before her, Laura has composed a more light-hearted work in which she has enjoyed portraying children, wearing attractive smocks and sun hats, in many different poses. This is typical of the more fun-loving mood of the Edwardian period, when a serious commitment to realism gave way to a delight in depicting the more frivolous

17. Alfred Munnings: *St Buryan Races*. 1914. Oil on canvas, 51 × 61cm (20 × 24in). Liverpool, Walker Art Gallery

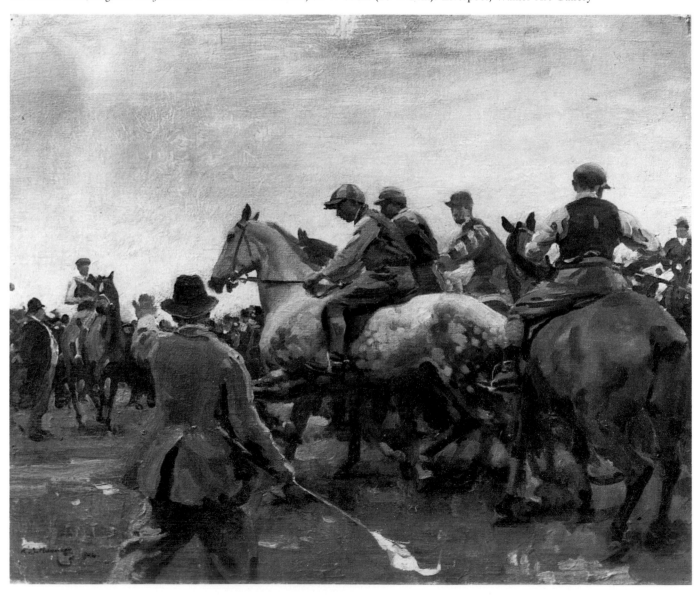

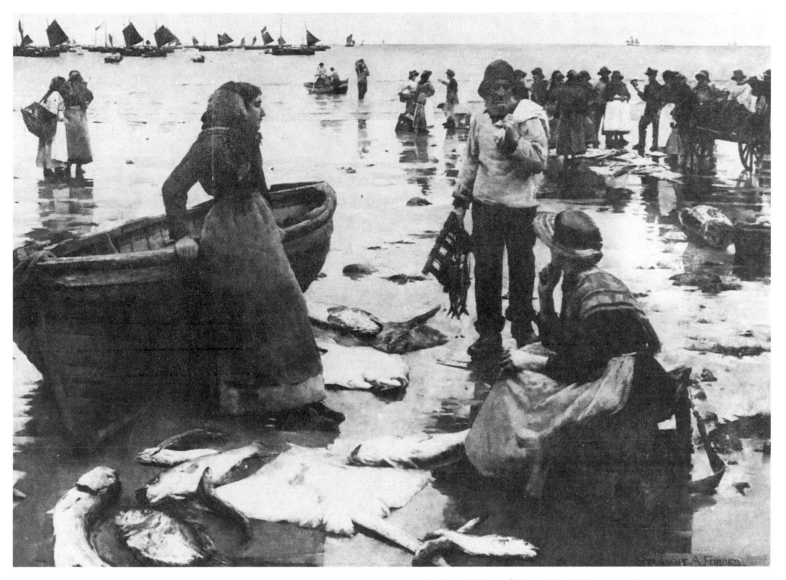

18. Stanhope Forbes: *A Fish Sale on a Cornish Beach*. 1885. Oil on canvas, 121.3 × 155cm (47¾ × 61in). Plymouth City Museum and Art Gallery

side of life. A further departure from the strict realism of the previous generation may be deduced from the actual setting of the scene, which, she stated, was much closer to Staithes than to Newlyn. *The Beach* expresses her joy at being in Cornwall and her love of painting sunlight, and is painted with all the verve and joyfulness of her following Newlyn works, demonstrating a great freedom and facility in the use of her brush.

The two Royal Academy submissions of 1910, *The Boys* (Pls. 21 and 22) and *Flying a Kite* (Pl. 24), continue this trend. Oil sketches for the latter reveal a simpler composition with fewer figures and very little view of the harbour. Both the sketches and the finished oil show her very free and dramatic handling of paint. She has delighted in rendering the effects of a stormy day and as in *The Beach* has concentrated on painting contrasting

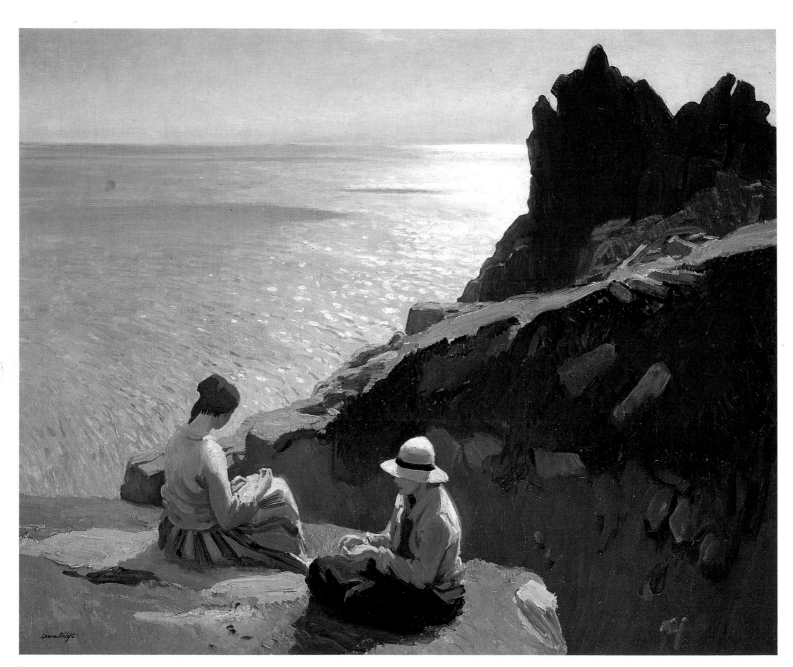

19. *On the Cliffs. c.*1917. Oil on canvas, 63.5 × 76cm (25 × 30in). Courtesy Mr and Mrs Dugan Chapman

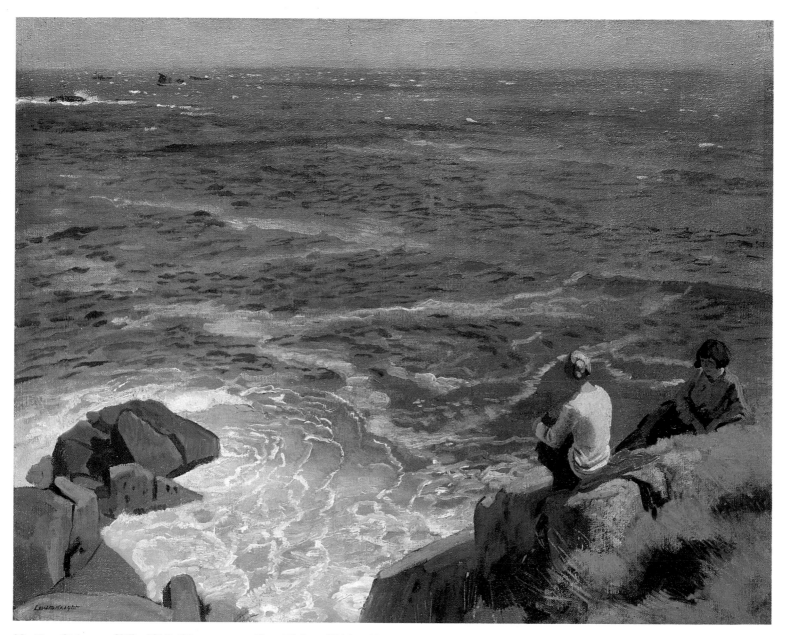

20. *Two Girls on a Cliff.* *c.*1917. Oil on canvas, 60 × 72.5cm (23½ × 28½in). Sotheby's

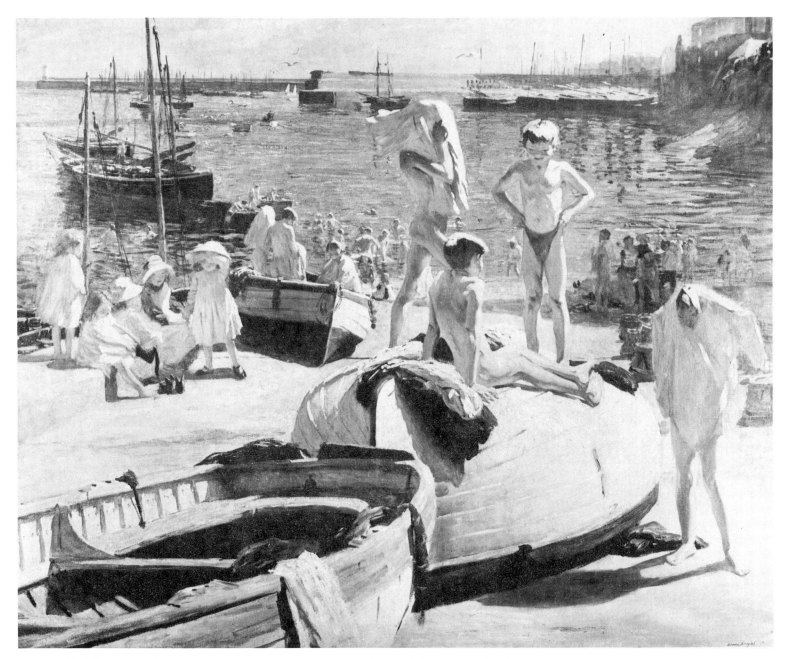

21. *The Boys*. 1910. Oil on canvas, 152.2 × 183.5cm (60 × 72¼in). Johannesburg Art Gallery

areas of brilliant light and dark shadow. She has also succeeded in portraying the vast scope and distance of the landscape before her.

 The Boys depicts a group of boys in the foreground dressing on an upturned boat which forms the focus of the composition, while also leading the eye to the groups of children and the harbour beyond. Studies for the group of girls on the left reveal that Laura altered their position at least once before she was satisfied with it.

 Laura began to make her name with these paintings. All three were exhibited at the Royal Academy and

22. Varnishing Day at Newlyn Art Gallery: Laura Knight with *The Boys*. Photograph. Private Collection

The Beach was widely admired not only by Munnings and other Newlyn artists but also by London gallery-goers. Mrs Asquith, wife of the future Prime Minister, was overheard to say at the Royal Academy Private View: 'Who is this Laura Knight?' *The Boys* and *Flying a Kite* were bought by Sir Hugh Lane for South African art galleries.

Laura was delighted with this success, which greatly increased her confidence, enabling her to move further away from the realist tradition and find a subject-matter which was all her own. She started to paint women, instead of children, sometimes in the nude and usually out of doors. The successful sales of her previous

works made it possible to hire professional models from London (Pl. 25) who were far more reliable than local girls and did not object to posing in the nude, despite the disapproval of local people. More important, she was establishing a new precedent. It had previously been unknown for a woman to paint the female nude out of doors.

Daughters of the Sun was completed in 1911 from large studies made in the true *plein air* tradition, Laura later marvelling at how she managed to carry six-foot canvases on her head while negotiating slippery rocks. This painting, now sadly destroyed after being damaged in the war, helped establish her reputation as a 'painter of the nude in sunlight'. It shows women in various stages of undress sitting near a rocky inlet of the sea. The two women in the foreground are skilfully placed, one leaning back and the other forward to lead the eye to the smaller groups of figures beyond.

Female figures, dressed and sitting on the edge of a cliff outlined against the sea, continued to be a popular subject with Laura for many years. These paintings (Pls. 19, 20, 30) are extremely bright and colourful and reveal her delight in painting the sea in its different moods with shimmering reflections and ripples around the rocks. Her models serve as focal points in these works and as colour contrasts to the rich blues and blue-greens of the sea. *On the Cliffs* (Pl. 19) is particularly dramatic in the use of dark purple shadow on the cliff face contrasting with the light falling on parts of the figures and on the sea beyond.

When unable to obtain or afford other models, Laura portrayed her fellow artists, sometimes with their children. The daughters of Lamorna Birch occur frequently in her paintings of these years (Pl. 28). The vast *Lamorna Birch and his Daughters* (Pl. 26), begun in 1913 and completed many years later during the 1930s, is one of Laura's early essays at working on a huge scale. Its full impact can only be gauged by seeing the actual painting. It dominates by its sheer size, its use of brilliant colour and the strength and breadth of the handling of the paint. Although a far more lyrical work, in its vigour and use of paint it foreshadows Laura's war paintings of the 1940s. This work may be seen as one of the best examples of the strength and solid brushwork of her mature style.

An example of pure bravado is the painting entitled *The Green Feather* (Pl. 29), featuring Laura's model of the time, Dolly Snell, wearing an emerald evening dress and a hat with a feather. The picture was painted in the course of one day and actually had to be repainted during that same day because of a weather change. Laura said that she used three pounds of white flake during the painting of it. Harold did not approve of her show of bravado, but his brother Edwin, who was staying with the Knights at the time, was a constant source of support, supplying Laura and her model (whom he later married) with cups of coffee and sandwiches at regular intervals. Laura described her state of mind at the time:

> An ebullient vitality made me want to paint the whole world and say how glorious it was to be young and strong and able to splash with paint on canvas any old thing one saw, without stint of materials or oneself, the result of a year or two of vigour and enjoyment.

The Green Feather was bought for the National Gallery of Ottawa, Canada, for £400 and Laura concluded that it was the best price she had ever had for a day's work! Another striking work of this period was the *Self-Portrait with Nude* (frontispiece) of 1913, for which her fellow artist, Ella Naper, acted as a model. The composition is an interesting one, showing the artist herself in the foreground and a full-length view of her nude model. The inclusion of a self-portrait with a nude model might have been found in the work of artists such as Sickert or Orpen at this time, but had never before been seen in the work of a woman artist. Thus Laura was creating another precedent as well as showing increasing boldness and confidence. The red cardigan she is wearing,

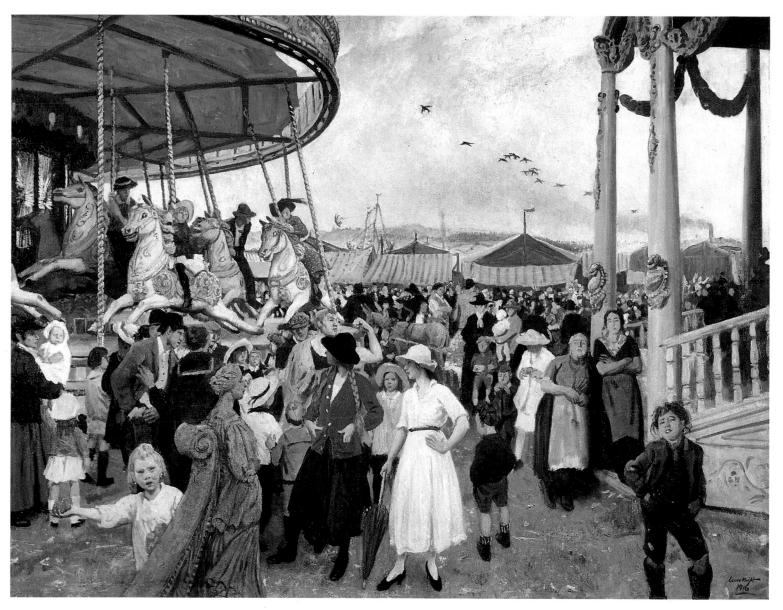

23. *Penzance Fair*. 1916. Oil on canvas, 116.8 × 151.1cm (46 × 59½in). Collection Richard Green

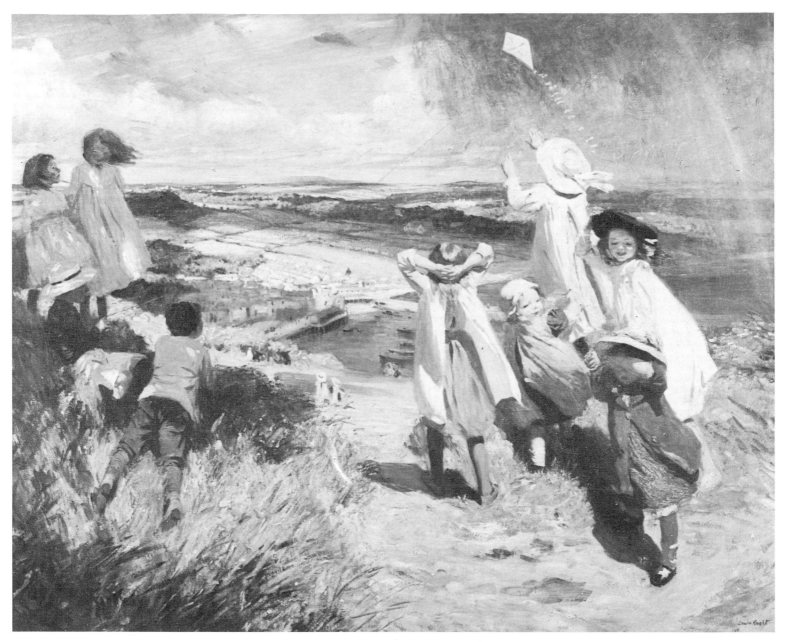

24. *Flying a Kite.* 1910. Oil on canvas, 150 × 180cm (59 × 70⅞in). Cape Town, South African National Gallery

known as 'The Cornish Scarlet', was much favoured by herself and others when posing for paintings. Laura recorded that it had been purchased for half a crown at a Penzance jumble sale.

In contrast to the previous paintings, *Spring* (Pl. 27) is a much softer work and expresses the gentle mood of the Lamorna countryside. Her two friends, Charles and Ella Naper, feature in the foreground. Later in life Laura recalled 'the extraordinary beauty of Cornwall, unique in Spring. I can again see the hedges, walls all aglow with primroses, violets and anemones with the golden gorsebush ablaze on the top all outlined by the beauty of the sky.' Surprisingly, *Spring* is one of the very few landscapes she painted there.

The fair at Penzance was a subject which attracted several of the Newlyn artists, including Laura, at this time. Laura had always been intrigued by fairs since her first introduction to the Nottingham Goose Fair as a child. She loved 'mingling with a big crowd' and was fascinated by 'the gilt and the colour, the worn grass, the sun and even the rain and wind'. In 1916 she painted two versions of *Penzance Fair* (Pl. 23). In both versions she includes herself looking characteristically younger than her 39 years, with long fair plaits and her hands stuffed into the pockets of her red cardigan.

For some of her most delicate paintings of these years, Laura employed the medium of watercolour. It was a medium she had used to great effect while in Staithes and one of her early successes was *Cheyne Walk* (Pl. 32), shown at the Royal Academy in 1909. Laura was at her most restrained in her use of watercolour and gouache and *Wind and Sun* (Pl. 31) is one of the most beautiful of all. Two girls are sitting on a cliff-edge against a background

25. *Cornwall*. 1912. Black chalk and watercolour, 54 × 76.2cm (21¼ × 30in). London, Editions Graphiques Gallery

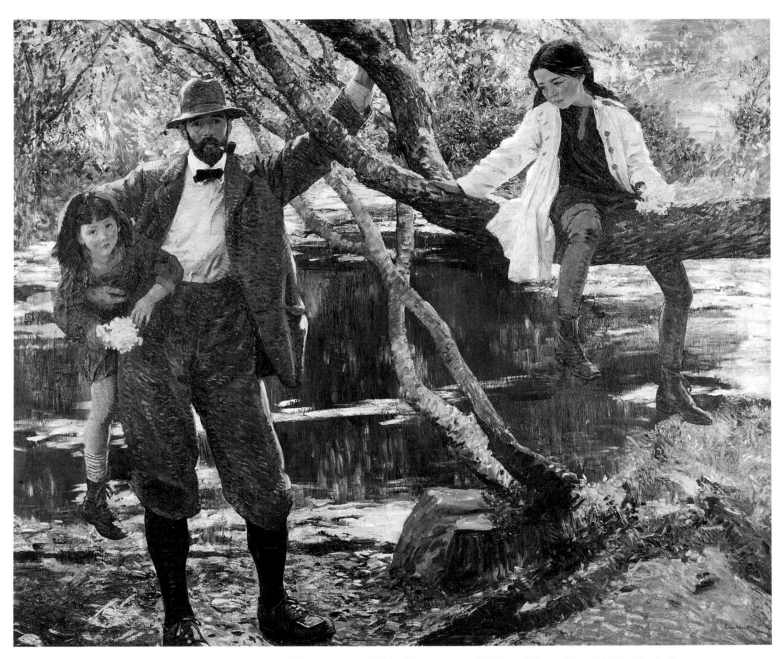

26. *Lamorna Birch and his Daughters.* Begun 1913, completed 1934. Oil on canvas, 228.6 × 272cm (90 × 107in). Nottingham University

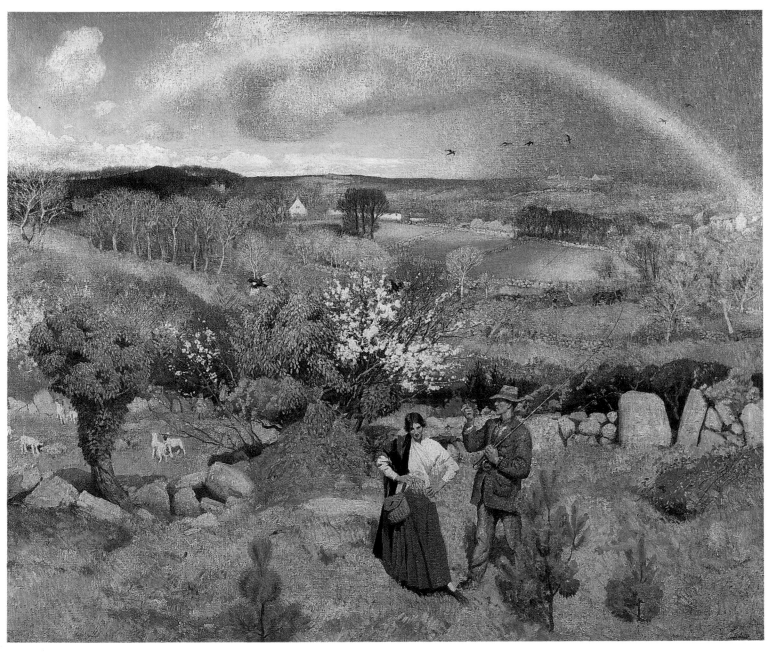

27. *Spring.* 1916. Oil on canvas, 152.4 × 182.9cm (60 × 72in). London, Tate Gallery

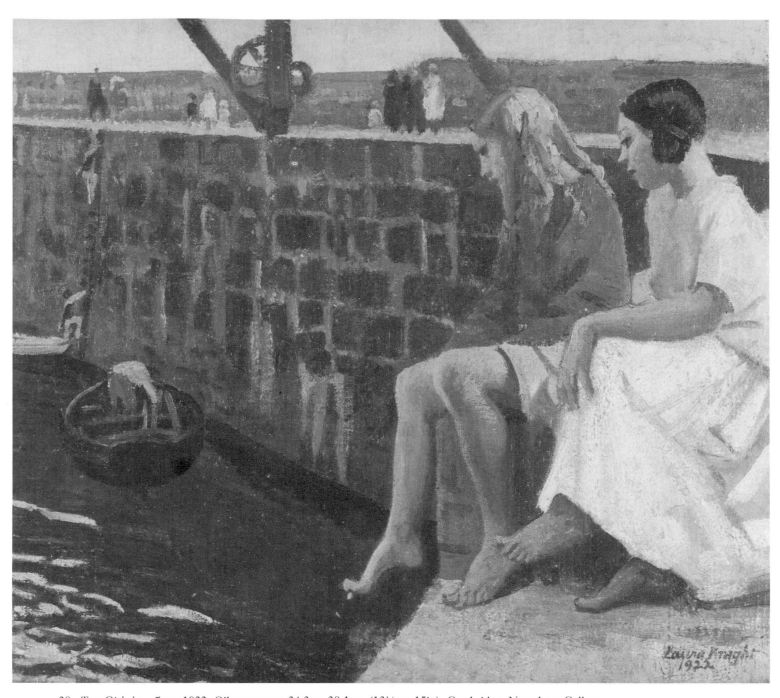

28. *Two Girls by a Jetty*. 1922. Oil on canvas, 34.3 × 38.1cm (13½ × 15in). Cambridge, Newnham College

of sea and the most exquisitely painted cloudy sky. Her watercolour portrait of two Lamorna artists, Robert and Eleanor Hughes (Pl. 33), is simply and affectionately painted, conveying the gentle personalities of this newly engaged pair. Another soft watercolour study shows two girls reading in a garden (Pl. 34). The extreme refinement and delicacy of her watercolours contrast with the much broader brushwork of her oil paintings, as her critics have been quick to emphasize, and altogether, her Cornish watercolours are some of the finest she ever produced.

The First World War broke up the pattern of life among the second generation of Newlyn artists. Laura

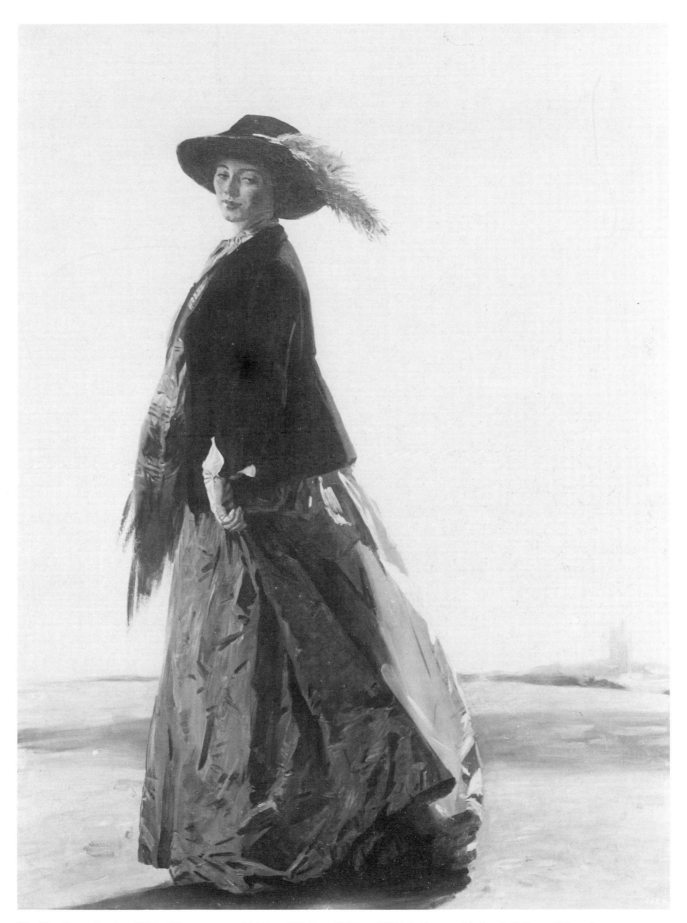

29. *The Green Feather*. 1911. Oil on canvas, 214.7 × 153.3cm (84½ × 63⅜in). Ottawa, National Gallery of Canada

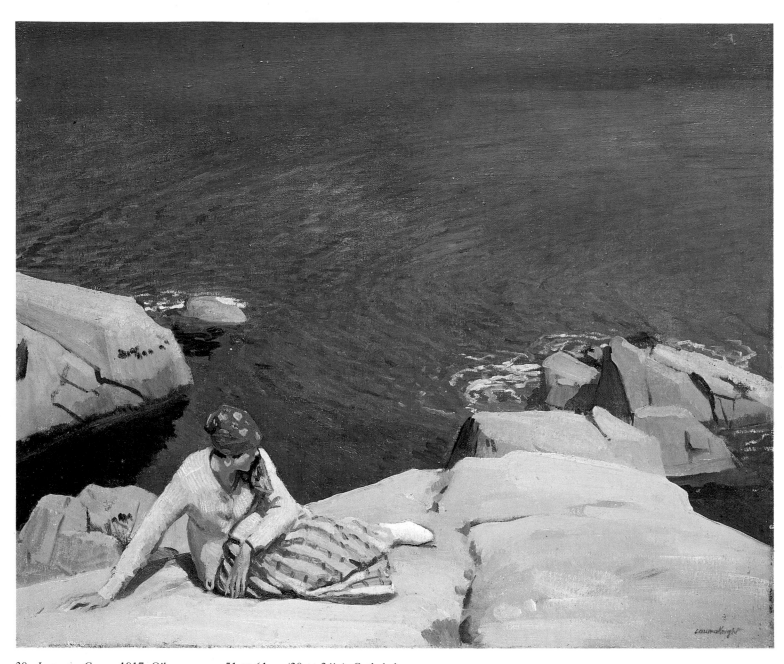

30. *Lamorna Cove. c.*1917. Oil on canvas, 51 × 61cm (20 × 24in). Sotheby's

31. *Wind and Sun. c.*1913. Gouache and watercolour on linen over pencil, 96.5 × 112cm (38 × 44in). London, Pyms Gallery

32. *Cheyne Walk*. 1909. Watercolour and bodycolour, 49 × 60.4cm (19¼ × 23¾in). Leeds City Art Gallery

continued to paint with her usual zest, but was irked by the restrictions on painting the coastline imposed by government censorship. When painting *Spring* she had to 'lie on my stomach under a gorse-bush or other convenient bush in dread of being taken off to prison, to make a line or two in a sketch book, memorise – rush back to my studio and paint.' As Munnings wrote in his autobiography: 'In August 1914 much of the work and all of the play was suddenly at an end.' In 1916 Laura was asked by P.C. Konody to execute a canvas for the Canadian War Records on the theme of Physical Training in a Camp. She chose to do two boxers and went to great pains to capture the correct stance.

The end of the war saw the departure of Munnings and of the Knights, who moved to London. This was to enable Harold to be on the spot for his portrait commissions which provided the couple with a basic source of

33. *Portrait of Robert and Eleanor Hughes in an Open Landscape. c.*1910. Watercolour on paper mounted on card, 52.1 × 36.9cm (20½ × 14½in). Private Collection

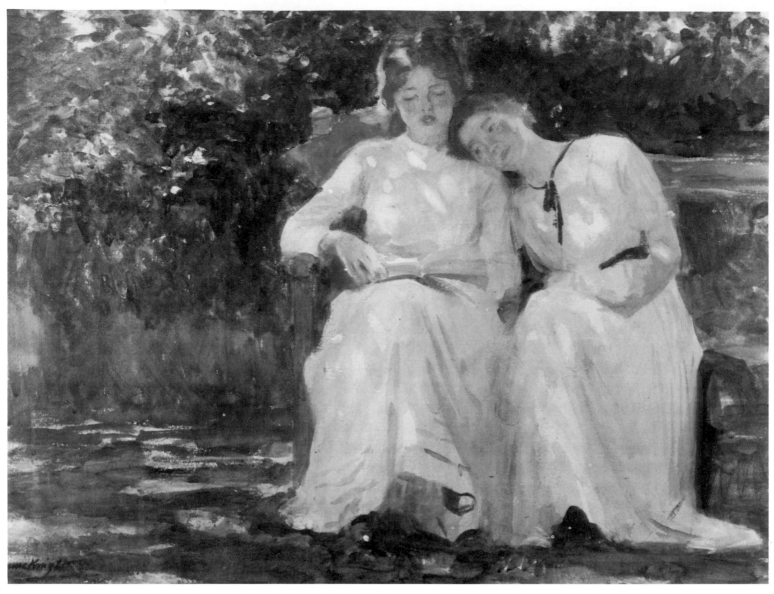

34. *Two Girls reading in a Sunlit Garden.* c.1914. Watercolour on paper, 51.4 × 74.3cm (20¼ × 29¼in). Doncaster, Museum & Art Gallery

income. Laura was extremely sad to leave Cornwall and admitted years later to shedding many tears secretly at being 'fastened tight in the masses of bricks and mortar'. There is no doubt that Cornwall always held a special place in her heart. The friendships made there were to last for the rest of her life. The Knights kept their Lamorna studios for some years, using them as a base for summer visits, and Laura continued to exhibit paintings of Cornwall at the Royal Academy. The Cornish years may be seen as one of the happiest and most creative periods of her life during which she produced some of her best work.

3
London: The Ballet and the Theatre

*'What more could any artist want? In London City it is
possible to be lifted in the fraction of a second from the depths to the
heights!'*

The move to London in 1919 marked the beginning of a period of change in Laura's work and in many ways set the pattern for the rest of her life. Although she continued to exhibit paintings of Cornwall throughout the 1920s, she was becoming increasingly absorbed in entirely new subject-matter – the ballet, theatre and, later, the circus. She also experimented with new techniques such as etching and aquatint in which she soon came to excel. Altogether, this was an extremely fruitful period.

It was Laura's own personal love of the ballet and theatre which encouraged her to use them as subjects for her art. From an early age she had enjoyed performing or reciting before an audience and when living in Cornwall had taken singing and ballet lessons. She loved the excitement of a performance, whether ballet, theatre or the circus, and the fun of being involved in it all. During their visits to London from Cornwall, the Knights had spent much time at the theatre and in Laura's words, 'would come away only when we had seen every play that was running'. They had also been to the pre-war (1910–14) performances of Diaghilev's Ballets Russes and seen Pavlova and Karsavina dancing with Nijinsky. Laura was completely captivated by Pavlova and indeed by the whole of Diaghilev's ballet.

When Diaghilev's Ballets Russes returned to London in 1919, Laura received permission to work backstage and had the great privilege of seeing this world-famous ballet at close quarters. She came to know the star ballerina Lopokova, who allowed her to sit in her dressing-room and sketch her while she dressed and made-up. Lopokova also introduced Laura to the famous and then ageing dancer, Cecchetti, who permitted Laura to draw the pupils who attended his morning dance classes. Perhaps Laura's greatest triumph was an invitation from Pavlova to go to her home and make some drawings of her for a book.

Not only did Laura meet some of the most famous ballet dancers of her day but her contacts with them also gave her opportunities for improving her drawing. Previously, she had concentrated on painting and had been rather ashamed of her drawing. Working with the ballet forced her to produce quick drawings and with practice her drawing became freer and more economical so that she was soon able to express herself in a few lines. Her drawing of Pavlova's profile (Pl. 35) shows her newly acquired facility to reduce line to a minimum. Equally successful is a drawing of one of Cecchetti's pupils (Pl. 36). Accuracy was important here, for if she made a mistake in the drawing, Cecchetti would blame the dancer and not Laura.

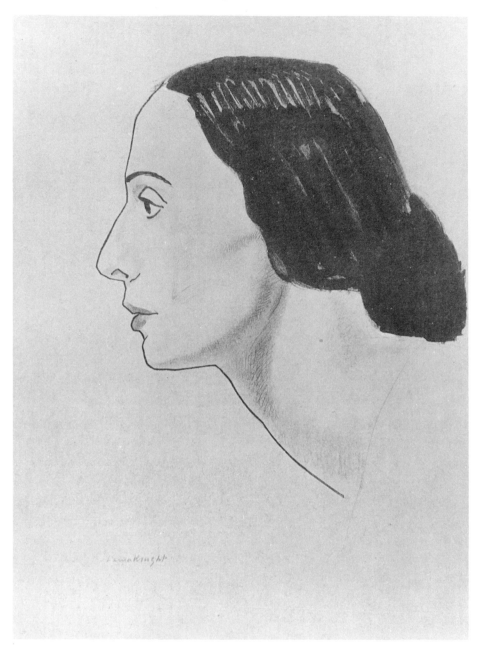

35. *Anna Pavlova*. Pencil, 35.5 × 25.4cm (14 × 10in). Sotheby's

Two major oil paintings of the ballet dating from the early 1920s, *Les Sylphides* (Birmingham Museum & Art Gallery) and '*Carnaval*' (Pl. 39), were both painted from sketches. The former features Lopokova, and the latter shows the moment before the rise of the curtain for a performance of *Carnaval* in 1920. Both these paintings are stiff and formal and show the stage as viewed directly from the auditorium. As compositions, they are not nearly as interesting as the music-hall and theatre scenes painted by Sickert and Spencer Gore during the early 1900s. Sickert was fascinated by the music-hall audiences which he sometimes painted with little or no reference to the stage (e.g. *Noctes Ambrosianae*, 1906). Spencer Gore brought life to his interpretation by showing the stage floodlit before the silhouetted heads of the audience and the orchestra in the darkened auditorium (e.g. *The Mad Pierrot, the Alhambra*, 1905). Both interpretations derive from Degas. Laura achieved more spontaneity and

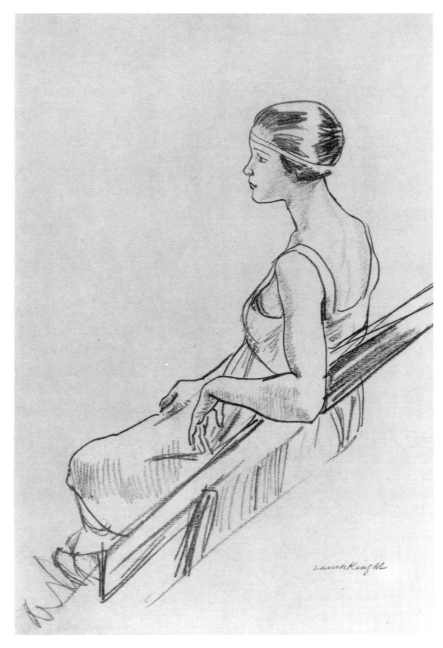

36. *A Dancer Resting.* Pencil. Whereabouts unknown

freedom with her informal stage and dressing-room scenes. *Ballet* (Pl. 37), showing two girls waiting in the wings, is a more relaxed composition and the seated figures express something of the grace and elegance of the ballet.

One of her most sympathetic paintings of the ballet is *The Ballet Girl and Dressmaker* of 1930, of which a watercolour study of the girl belongs to the Castle Museum in Nottingham (Pl. 38). The painting was commissioned by an American business man, Earl Hoover, and features Barbara Bonner as the dancer with Laura's own dressmaker. There is a simple honesty in this painting and Laura herself stated that it was 'one of those paintings which went from start to finish without any alteration. One of those lucky ones which paint themselves without disagreement with the painter.' Its quality was recognized and it was much praised by the critics and widely reproduced in the States. Indeed, Laura even received a letter of admiration from two American cowboys!

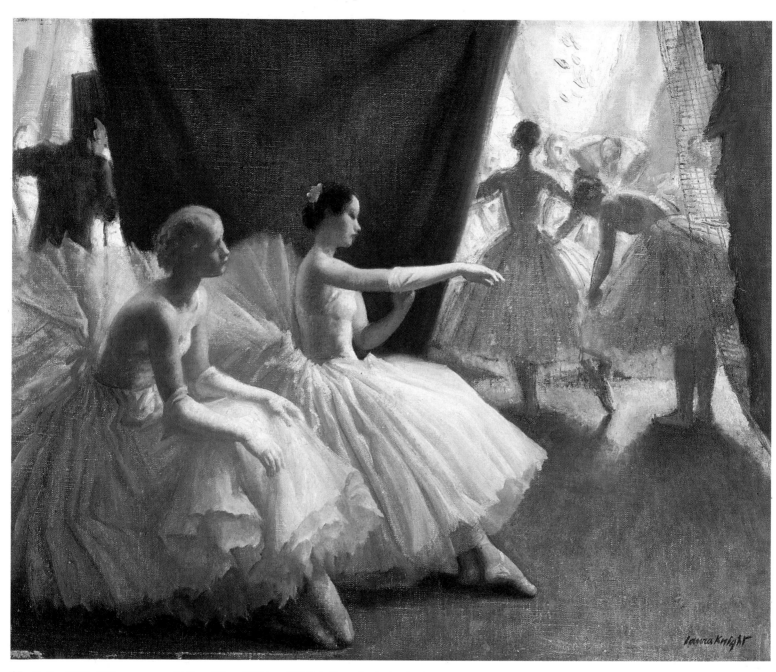

37. *Ballet*. 1936. Oil on canvas, 64.8 × 77cm (25½ × 30⅜in). Port Sunlight, Lady Lever Art Gallery

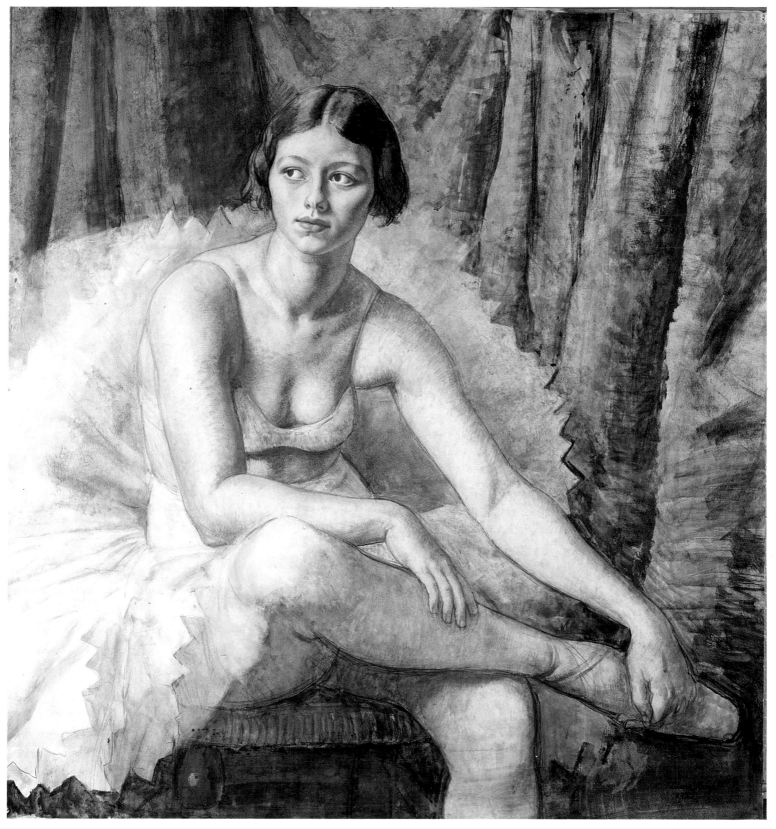

38. *A Ballet Dancer.* 1932. Watercolour and bodycolour, charcoal, conté and sanguine, 91.5 × 86.4cm (36 × 34in). Nottingham Castle Museum

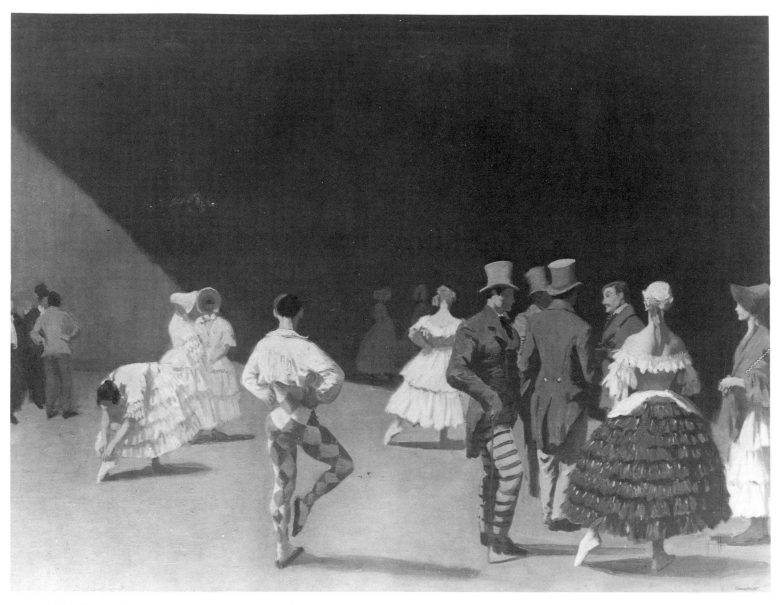

39. *'Carnaval'*. 1920. Oil on canvas, 101.6 × 132.5cm (40 × 52½in). Manchester City Art Galleries

Laura was undoubtedly happiest when painting informal scenes backstage or dancers in their dressing-rooms. She was delighted with all aspects of Pavlova's untidy dressing-room including the Cockney dressers. Pavlova, however, could not understand this at all and requested that 'Mrs Knight confine her attentions to the stage'. Laura had also felt very much at home in Lopokova's dressing-room where she found 'everything glorious to paint'. Her dressing-room paintings express this joy in her surroundings and a particularly striking example may be seen in Plate 41. The bright colour and patterning of the women's robes gives the painting its particular zest, while the use of the mirror reflections adds another dimension to the composition. The composition of *The Theatre Dressing-Room* (Pl. 40) is equally arresting, both in the positioning of the woman at the basin and in the rich painting of the folds of her dress. In two paintings showing ballerinas in their dressing-rooms *The Ballet Shoe* (Pl. 42) and *A Dressing-Room at Drury Lane* (Pl. 45), she has concentrated on the subtle intricacies of the ballerinas' dresses, all of which are executed with extreme skill.

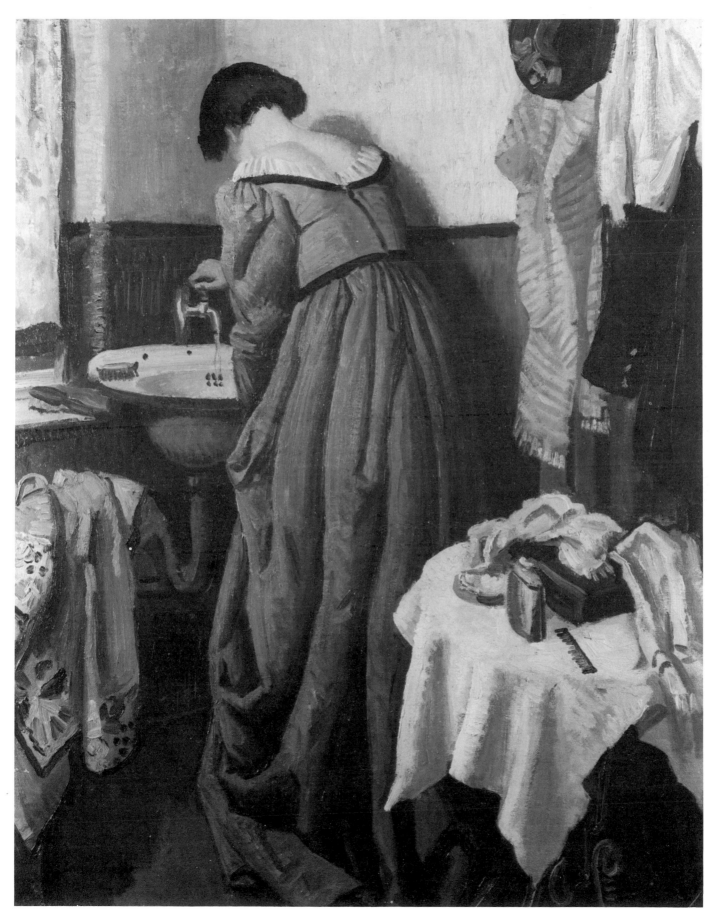

40. *The Theatre Dressing-Room. c.*1935. Oil on canvas, 74.3 × 62.9cm (29½ × 24¾in). Glasgow Art Gallery and Museum

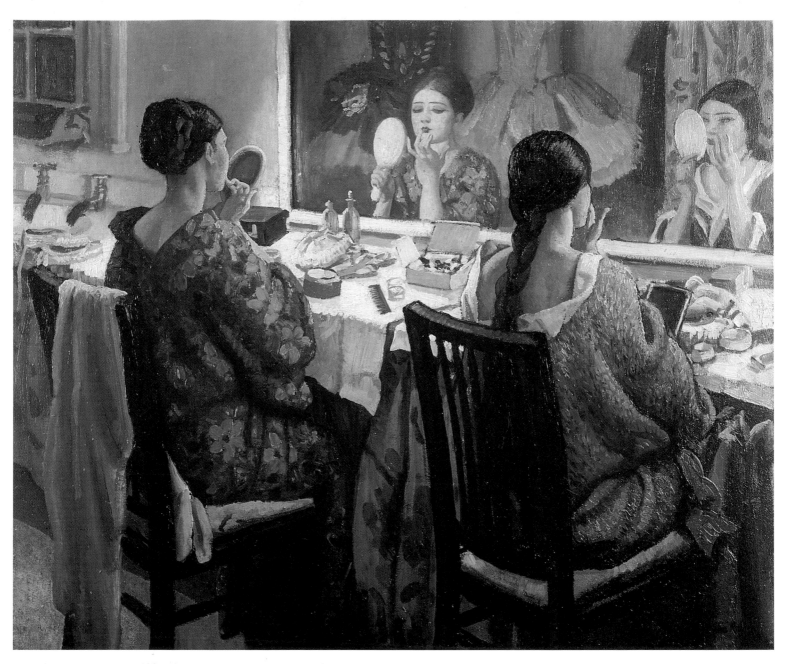

41. *The Dressing-Room. c.*1924. Oil on canvas, 63.5 × 76cm (25 × 30in). Manya Igel Fine Art

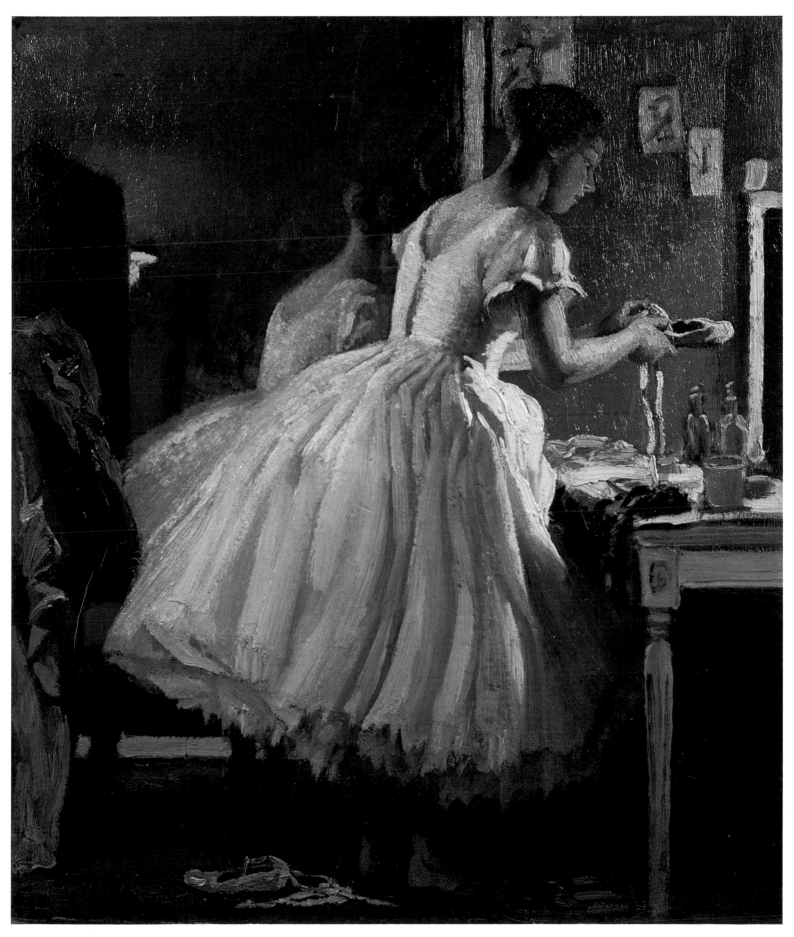

42. *The Ballet Shoe*. 1932. Oil on board, 46 × 40cm (18⅛ × 15¾in). Brighton, Royal Pavilion Art Gallery and Museums

43. *Make-up*. 1925. Etching, first state, 25.4 × 20cm (10 × 7⅞in). London, Belgrave Gallery

After a short stay in Hampstead the Knights moved to two unfurnished studios in St John's Wood. At one point, Laura rented Roger Fry's studio, but never actually used it. On the whole there seems to have been little contact with the Bloomsbury group. But the Knights soon began to build up a wide circle of friends which included many other artists as well as musicians, composers, writers, poets and dancers, many of whom they met at the Café Royal or through Laura's contacts with the ballet and theatre. It was at the Café Royal that they first met the poet W. H. Davies, author of *Autobiography of a Super Tramp*. He was painted by Harold on several occasions and joined them on one of their visits to Cornwall. It was through the ballet that they came to know the pianists Ethel Bartlett and Rae Robertson who were to become close friends until they moved to the United States. Ethel Bartlett modelled for Harold many times and a painting of her by Laura belongs to the Atkinson Art Gallery in Southport.

The Bartlett-Robertsons used to practise on the two grand pianos in Harold's large studio at 16 Langford Place, St John's Wood – the Knights' latest and permanent London address. The studio was also used by other eminent musicians, including Sir John Barbirolli, who became a very good friend, Jan Smeterlin, who gave his first concert there, Harriet Cohen and Miriam Licette. Laura was also acquainted with the composer Arnold Bax, who saw a relationship between their work and particularly admired her rock and sea paintings.

Laura owed her opportunities for working behind the scenes in the theatre to her friendship with Sir Barry Jackson, who ran the famous Birmingham Repertory Company. They had first met in Cornwall when Jackson had gone there to have his portrait painted by Munnings. Later, Jackson and his actor friend Scott Sunderland had been quartered in Newlyn during the First World War, and after meeting again in London during the early 1920s, the Knights became regular visitors to Jackson's home near Birmingham.

The Knights had the good fortune to see some of the Birmingham Rep's most important productions of the 1920s, including the memorable *Immortal Hour*, which starred Gwen Ffrangçon-Davies and Herbert Simmonds, *Bethlehem* and *Romeo and Juliet* in which John Gielgud starred with Gwen Ffrangçon-Davies. Laura made watercolour studies of *The Marvellous History of St Bernard* performed in London in 1926 and of *The Barretts of Wimpole Street*. The latter was performed at the Malvern Festival in 1930 and her lively watercolour (Pl. 44) shows Eileen Beldon holding Flush the dog, Gwen Ffrangçon-Davies in blue morning-dress and Cecil Hardwicke taking a curtain call. Once again, Laura relished working backstage and being involved with all the rush and bustle and was always ready to lend a hand herself when help was needed.

In the early 1920s Laura fell and broke her wrist. She was thus prevented from holding a palette, but nothing daunted, she decided to take up etching. She had acquired an old press and been much helped by John Everett, an Englishman whom she had met in Holland. She threw herself into etching with her usual energy finding it an exciting and stimulating process which enabled her to express movement in line in a new way. She soon came to prefer the broader method of aquatint which she had taken up after studying Goya's *Caprichos*. Some of the most lively works of these years depict the dancers from the Quadro Flamenco, who had been brought over from Spain by Diaghilev (Pl. 46). The dancers were a great success with the London audiences and Laura's aquatints succeed in capturing their great sense of life and movement. Her bold use of aquatint in *Some Holiday* (Pl. 47) shows her delight in the raw and vulgar in total contrast to the very elegant *Make-up* (Pl. 43). The latter is again in sharp contrast to her drypoint of another dressing-room scene depicting three very muscular girls in different stages of undress (Pl. 48). Her etchings and aquatints form an outstanding body of work throughout the 1920s and deserve to be studied in their own right.

In 1922 Laura was asked to go over to the Carnegie Institute in Pittsburgh as a European representative, with the French artist Lucien Simon. The invitation, which Laura saw as a great honour, may be taken as some indication of her status in the eyes of the art world. It proved to be a most exciting experience and she visited New York, Washington, and Boston as well as Pittsburgh, being royally entertained all the while. Of all the paintings she saw there she was particularly moved by two El Grecos in the collection of Mrs Havemeyer in New York, *Toledo* and *The Cardinal* (both now in the Metropolitan Museum of Art).

The achievement of fame and honour, however, did not mean that the Knights were surrounded by great wealth, and on her return Laura found that Harold had been obliged to pawn all their valuables in order to pay the rent. It was also during the early 1920s that Harold became ill with pneumonia and their friend Barry Jackson lent them some money to keep them going. It is important to bear in mind that money worries were never far away and

44. *The Barretts of Wimpole Street: As seen from the Wings, Queen's Theatre*. 1930. Gouache and watercolour over chalk, 81 × 55.9cm (31⅞ × 22in). Birmingham Museum and Art Gallery

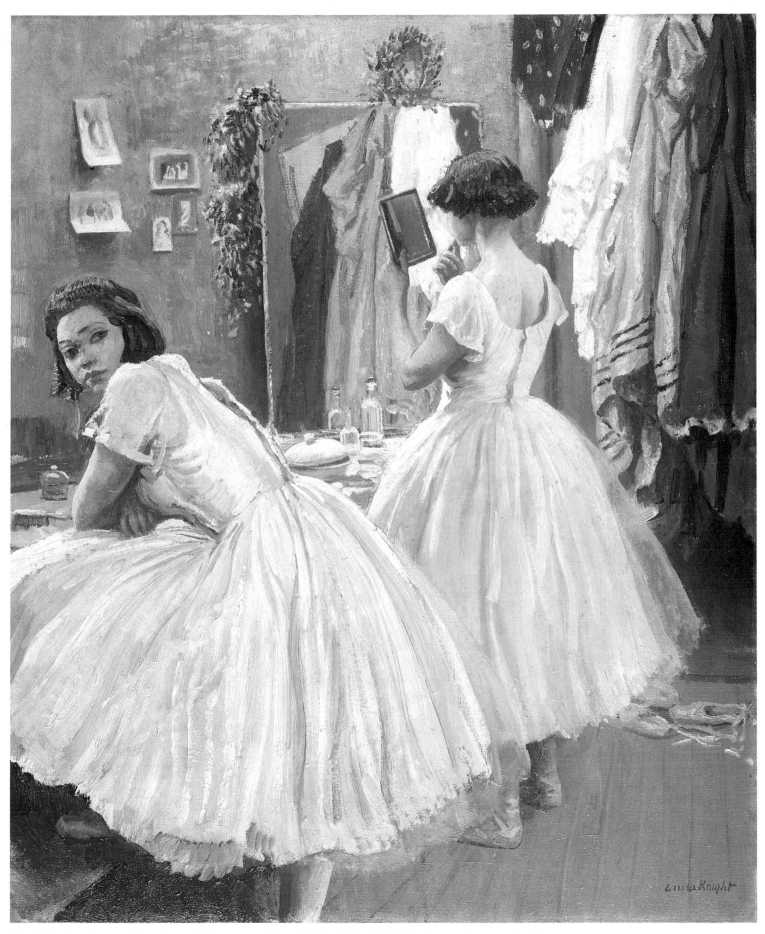

45. *A Dressing-Room at Drury Lane*. Oil on canvas, 76 × 63.5cm (30 × 25in). Southport, Atkinson Art Gallery

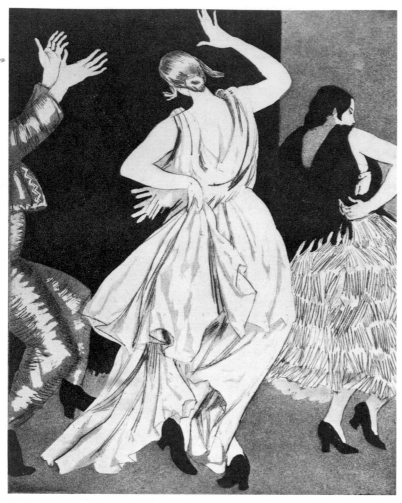

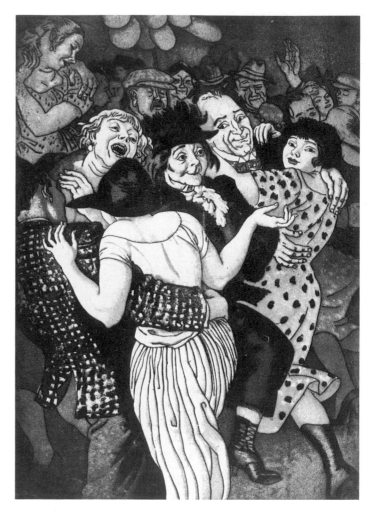

46. *Spanish Dancer, No. 1.* 1923. Etching, 21.6 × 26.7cm
(8½ × 10½in). Whereabouts unknown

47. *Some Holiday.* 1925. Aquatint, 35.2 × 25cm
(13⅞ × 9⅞in). London, Belgrave Gallery

that this obviously affected their work and their reactions to it. The poor sales of her Cornish work may have led
Laura to concentrate on other more popular subject-matter. She wrote later:

> Throughout Harold's and my later life when we were both at the height of whatever fame we may have had
> and supposedly doing well, periods frequently came when we did not know where we should find the next
> quarter's rent. Fortunately, manna always seemed to fall from heaven each time to save us; but not until
> comparatively recent years did we both feel a little more certainty.

The poverty of their early years was so ingrained in them that even as late as 1946 when they were both established
painters with several houses to their name, Harold wrote in a letter to Laura in Nuremberg: 'This being apart is
very annoying, but I suppose we must make a bit of money while the going is good.'

In 1926 Harold received an invitation from a Dr Baer from Baltimore to go over there and paint some
portrait commissions. After a few months Harold received so many commissions that he wrote to Laura suggest-
ing that she go out and join him, and enclosing the money for a first-class boat ticket. Laura was thrilled with this
opportunity and when she reached Baltimore, in characteristic fashion, she began to explore an entirely new area
of subject-matter. Dr Baer introduced her to several of the hospitals in Baltimore, where she decided to

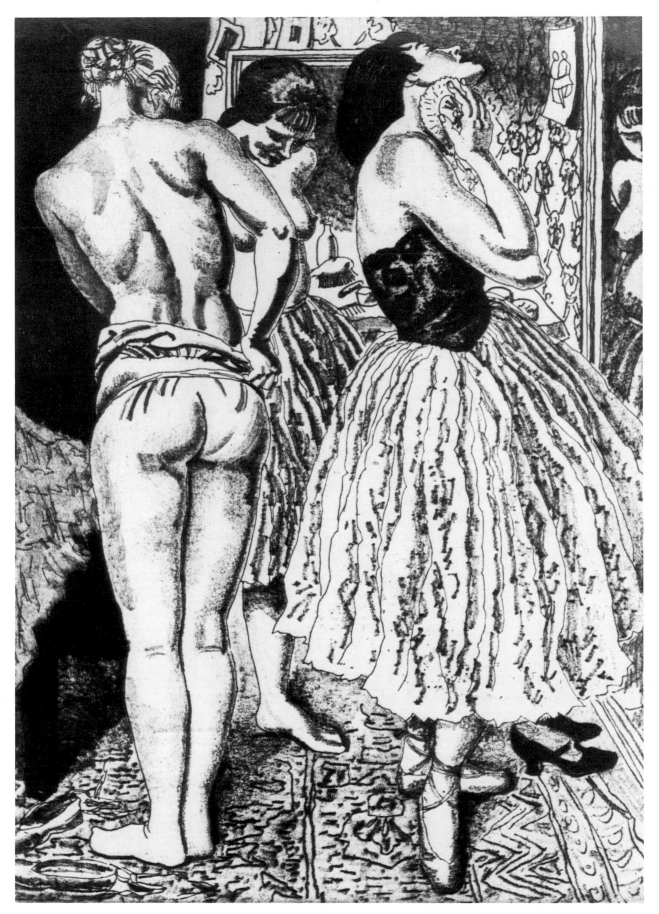

48. *Three Graces of the Ballet*. 1926. Etching, 35 × 24.8cm (13¾ × 9¾in). London, Belgrave Gallery

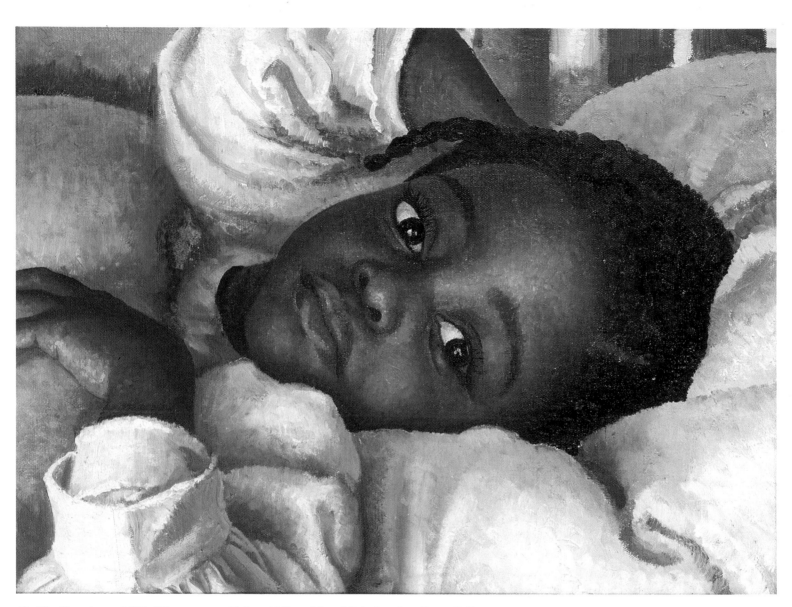

49. *The Piccaninny. c.*1927. Oil on canvas, 30.5 × 40.5cm (12 × 16in). London, Pyms Gallery

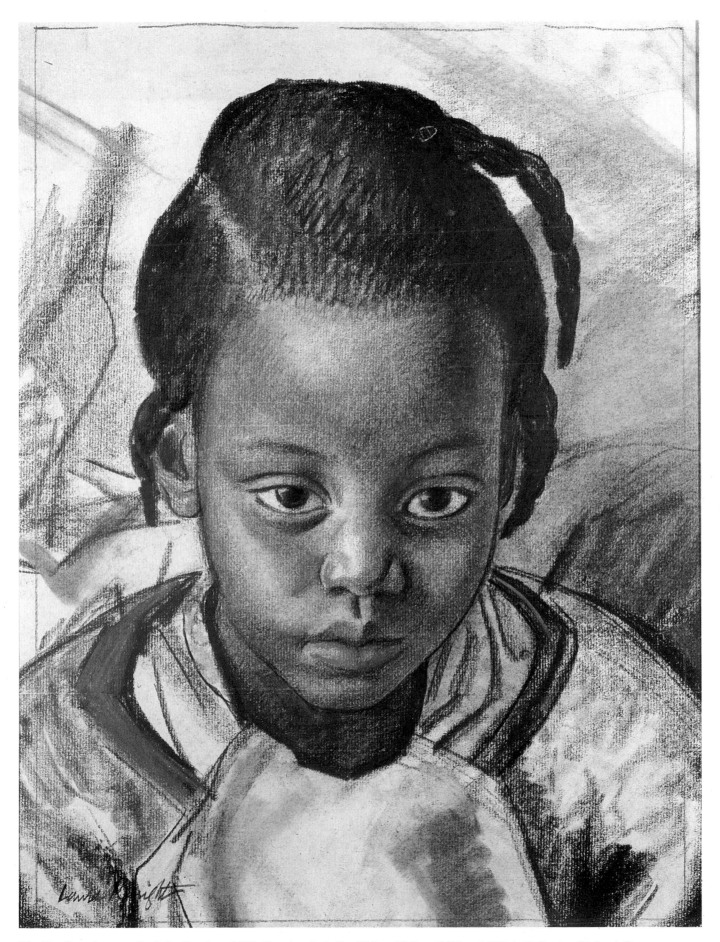

50. *The Convalescent – Study for Juanita. c.*1927. Pastel and chalks, 38.7 × 29.2cm (15¼ × 11½in). Collection Richard Green

concentrate on painting the Negro mothers and children. She later found herself a studio where she continued to employ Negro models.

There is no reason to assume that Laura was expressing particularly socialist tendencies in portraying these subjects. It is more likely that the idea originated from Dod Procter's paintings of Burmese children (1920) and that Laura chose to depict the Baltimore blacks because they were an unusual and exotic subject to paint at that time, and would have appeared so to an English audience. She was also fascinated by the play of light and colour, and *Darkie Baby*, *The Piccaninny* (Pl. 49), *The Convalescent* (Pl. 50) and *Madonna of the Cottonfields* are four of her finest examples.

Laura's moment of triumph came in 1927 when she was made an associate of the Royal Academy. She was only the second woman this century to gain this honour (Anne Swynnerton, the first, had succeeded in breaking down a great deal of prejudice against women members) and was thus placed in rather a special position. It was a happy combination of talent and personality which won her this public recognition. But it must also be remembered that the Royal Academy was the bastion of conservative academic painting and saw Laura as belonging to the same tradition. She had been a regular exhibitor there since her first submission in 1903, rarely missing a year and sometimes showing as many as three paintings. Later in life, during the 1930s and 1940s, she was showing up to six paintings some years.

In 1929, Laura received a further honour when she was made a Dame of the British Empire in recognition of her unique achievement as a woman artist in the twentieth century. It was a tribute to the appeal of her work to ordinary people for whom, over the years, she became a household name. In many ways the late 1920s coincided with the peak of her achievements: the best of these included her fresh and lively Cornish works, her ballet and theatre dressing-room scenes, her paintings of Negroes and her etchings. One can only speculate whether public pressures and early success may not have made her complacent and hindered her from continuing to develop her very real talents as shown in these works.

4
London: The Circus

'Never did I have happier companionship (apart from that of
Harold Knight) than with my circus pals.'

The famous Nottingham Goose Fair which Laura so vividly recalled from her childhood undoubtedly encouraged her to look to fairs, circuses and the gypsies as subjects for her art in later life. There were 'so many marvels to see', she wrote,

> even the shows outside were wonders – people dancing and 'tumbling' – the pictures of the fat woman, in evening dress, too . . . Crimson plush, satin, sequins made the show-people's costumes, the women's hats were feathered with ostrich plumes, and their skins were brown under the rouge and powder as they showed themselves off outside the booths, while the spieler shouted himself hoarse.

Laura's interest in folk life was shared by several artists and writers of her time who were anxious to record these rapidly vanishing ways of life. John, Munnings and Seago were all attracted by the freedom of the gypsies and used them as subjects for their art. In the same way that the artist colonies of the later nineteenth century had idealized village life, these later artists looked on colourful 'fringe' groups such as gypsies, fairs and circuses as epitomizing a more natural way of life in contrast to the encroaching urbanization of the twentieth century. Laura was also attracted by the colourful and exotic possibilities of portraying the circus with all its fun and excitement. She may well have seen it as an extension of her work with the ballet and theatre, and there was nothing she liked more than being fully involved in a show. As an artist, she felt an affinity with the circus performers and her relationships with them were some of the closest she ever made. She admired their courage, hard work and continual striving for perfection – qualities she herself shared with them (Pl. 51).

Laura first visited the circus at Olympia during the early 1920s and used to sketch from seats high up at the back of the audience. It was, however, a porter at Paddington station who told her to go to the 'real old-fashioned circus' in the agricultural hall at Islington. There she made many friends whom she was to meet again later, when in 1923/4 Munnings took her to Olympia and introduced her to Captain Bertram Mills. The latter had just started his circus, soon to become world-famous, and gave Laura permission to work in any part of the building. They became good friends and used to meet for lunch when they endlessly discussed the circus. She also made friends with the famous clown, Whimsical Walker, whom she painted in 1927 with his dog.

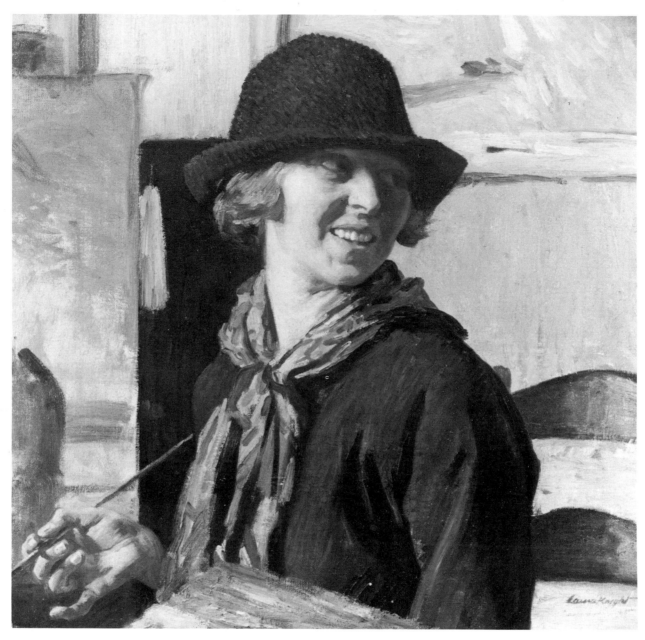

51. *Self-Portrait*. 1936. Oil on canvas, 59.5 × 59.5cm (23⅞ × 23⅞in). Wellington (New Zealand), National Art Gallery

The following year, Carmo's circus was at Olympia and Laura soon became familiar with the performers and their animals: Togare the lion-tamer and Paris the lion, the spotted horses (or knapstropers) and their riders, the zebras, the ponies, Mary the elephant, the dwarf and last, but not least, the clowns, whose wives took a motherly interest in Laura, making sure she was properly fed.

It was shortly after this that Laura received an unusual commission. She had made friends with an elderly gentleman called Major Atherly, also a tremendous circus enthusiast. The Major asked her to paint a picture which would include practically the entire circus, animals and performers, all together in one painting. Harold told her that it was impossible, but Laura could not resist the challenge and determined to have a go, beginning the sketches one summer while in Cornwall. The finished painting, *Charivari* or *The Grand Parade* (Pl. 52), is unusual

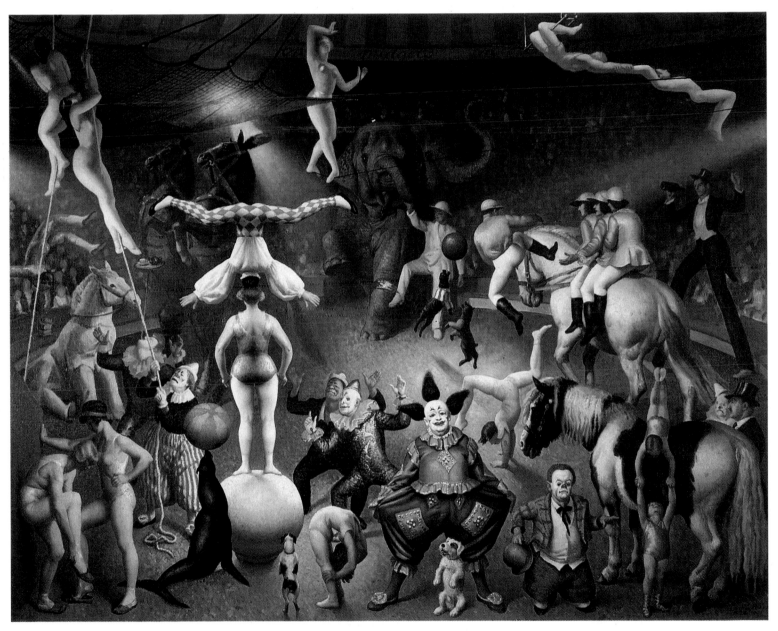

52. *Charivari* or *The Grand Parade*. 1928. Oil on canvas, 101.6 × 127cm (40 × 50in). Gwent, Newport Museum and Art Gallery

with its many-centred composition and not entirely successful. However, it was exhibited at the Royal Academy in 1929 and was caricatured in several of the newspapers.

In the early 1930s, Laura decided to join Carmo's circus on a tour of Midland towns. It was typical of her curiosity and enthusiasm to want to be so totally involved with her subject that she shared the life. Harold was horrified and quite unable to share her passion. He told her primly that she was 'circus crazy' and that 'she would do better work if she remembered she was an artist and not a performer'. But he was unable to prevent her from going. As she wrote: 'The circus held my whole interest. I was there all day; I could leave it only to go back to sleep.' The circus were delighted to have Laura with them and put her on the payroll as official artist at a salary of two and sixpence a week. This enabled her to circumvent the rule that outsiders were not allowed behind the scenes.

Laura was greatly encouraged by the performers, who made her feel very welcome and posed for her whenever possible (Pl. 53): 'Whenever I set up the easel I was in the way of something going in and out of the ring. I was accepted by owners, grooms and performers as an inevitable accompaniment of the show.' She spent much of her spare time with the clown Joe Bert and his wife, Ally, who were her special friends. They looked after the necessities of her life so that she could continue painting uninterrupted. The three used to share lodgings and in the evenings Joe and Ally would regale Laura with tales of their years with circuses in the east. Laura found these stories so enthralling that she eventually decided to write a book based on Joe's life. It was published many years later in 1962 under the title *A Proper Circus Omie* and was illustrated with her circus drawings. From a letter she wrote to the writer Paul Gallico in 1965, it appears to have been 'an absolute flop', unlike her two autobiographies which were both best-sellers.

Laura was often forced to work at great speed when painting the circus, with only a short glance at her subject, since they could rarely afford much time to pose for her. She always had to be prepared to move quickly for the animals could easily get loose and cause havoc. On one occasion her easel and paints were sent flying by horses coming out of the ring and on another she had to make a hasty exit when Baby June, the elephant, panicked. Sometimes she was painting ankle deep in mud. Inevitably, she had to give up attempting great subtleties in paint and ended by painting directly onto the canvas without preliminary drawing. This may explain the flat almost illustrative appearance of some of her circus paintings and she herself conceded much later in her life that the circus possibly provided too much entertainment for her to do her best work, adding that she found the gaiety overwhelming.

Some of her paintings of the large spotted horses and their riders appear flat and dull, the compositions over-fussy and the use of paint, crude and heavy (Pl. 54). The horses, however, are beautifully painted as she had plenty of opportunity to study them since the grooms used to hold them for hours while she sketched.

She was, on the whole, more successful with her paintings of clowns. The *Three Clowns* (Pl. 56) of 1930 features Joe Bert, Randy and Marba who posed for it at intervals between appearances, and who look natural and relaxed. The composition concentrates on the three figures and the eye is not distracted as in so many other of her circus paintings. Colour is also used more sensitively. Clowns were a subject to which she was to return over the years and perhaps one of the most delightful paintings of them is her *Old Time Clowns* (Pl. 55) of 1957. Painted with a very sparing, almost monochromatic, use of colour, it shows five clowns gazing wistfully out at the audience from the wings. She has somehow succeeded in capturing their different personalities with great subtlety and understanding.

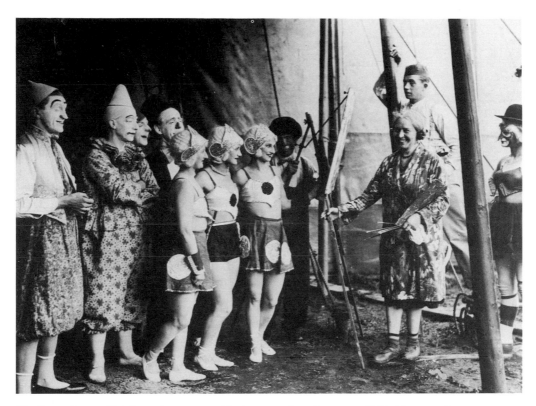

53. Dame Laura Knight under canvas with clowns and performers. *c.*1932. Photograph. Nottinghamshire Record Office

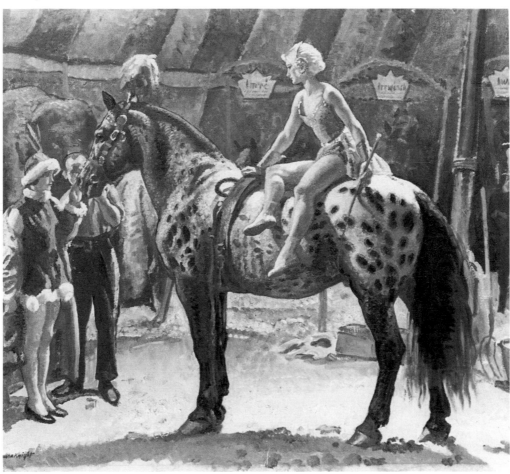

54. *Elsie on Hassan*. 1929/30. Oil on canvas, 68.6 × 76.2cm (27 × 30in). Nottingham Castle Museum

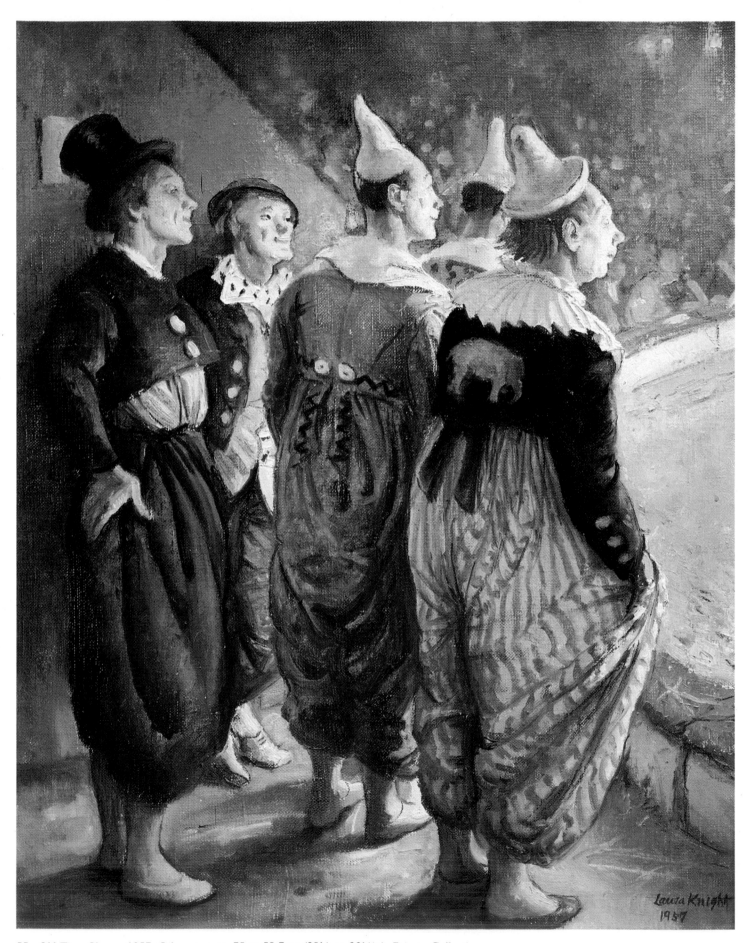

55. *Old Time Clowns*. 1957. Oil on canvas, 75 × 59.7cm (29½ × 23½in). Private Collection

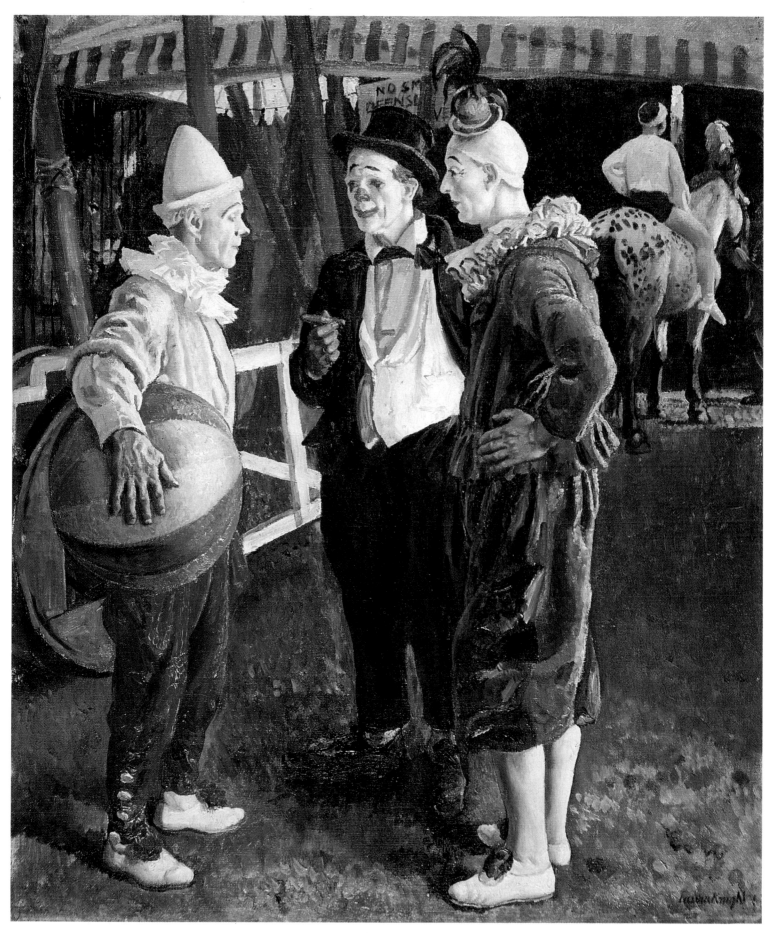

56. *Three Clowns*. 1930. Oil on canvas, 77 × 63.5cm (30¼ × 25in). Leicester Museums and Art Gallery

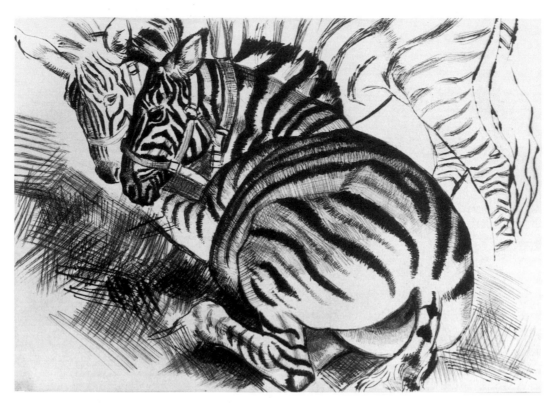

57. *Zebras*. 1930. Etching, first state, 24.8 × 35cm (9¾ × 13¾in). London, Belgrave Gallery

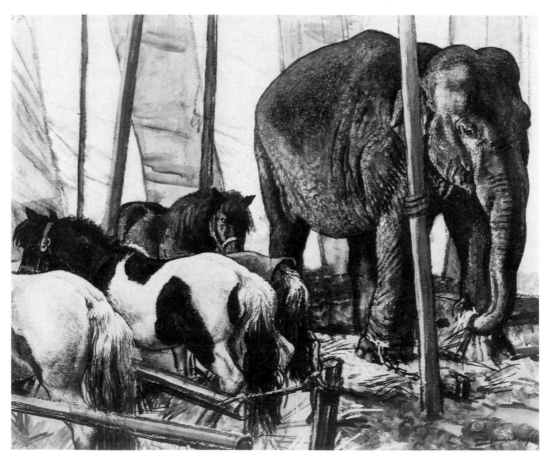

58. *Mary and the Shetland Ponies. c.*1930. Watercolour, 45.9 × 56.5cm (18⅛ × 22¼in). Newcastle upon Tyne, Laing Art Gallery

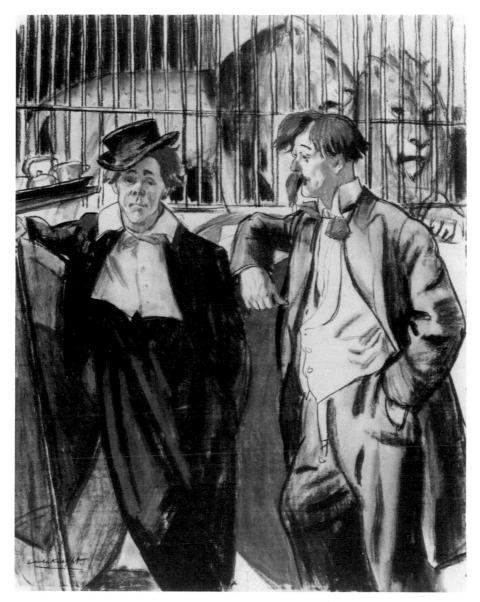

59. *Two O'Gusts and Two Lions. c.*1930. Charcoal, watercolour and body-colour,
149.9 × 118.1cm (59 × 46½in). Newcastle upon Tyne, Laing Art Gallery

Laura's watercolours of the circus were on the whole far more restrained than her oils. Watercolour was, as we have seen, a medium in which she always expressed a much greater degree of sensitivity and delicacy and a watercolour and gouache entitled *Mary and the Shetland Ponies* (Pl. 58) is a particularly good example. In another watercolour showing two clowns and two lions (Pl. 59), she has caught the clowns in an unguarded moment. Some of her drawings of the circus are very strong and full of life and a *Studio* article of 1932 on 'Animal Painting in Britain', which illustrated one of her drawings of an elephant, praised her power of draughtsmanship and design. In an etching of two zebras, by whom on one occasion she had narrowly missed being kicked, she has used their stripes to good decorative effect (Pl. 57).

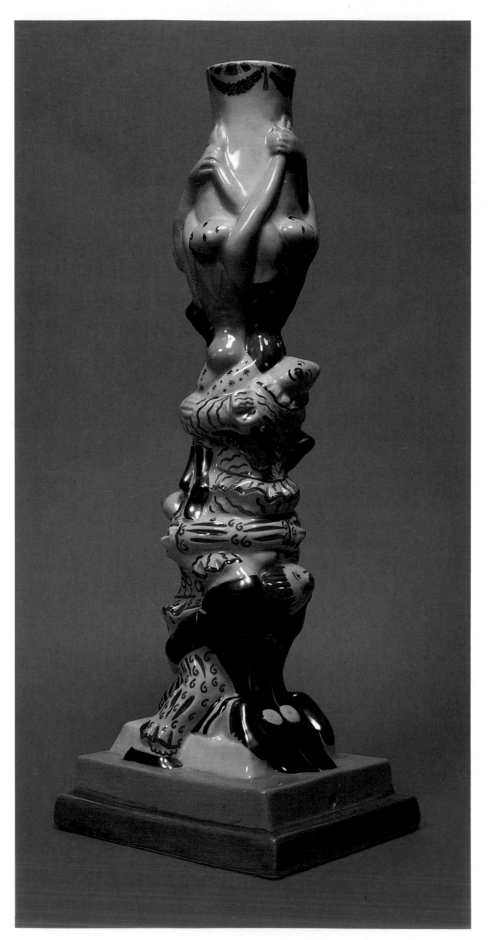

60. *Lampstand*. 1934. Cream-coloured
earthenware, hand-painted with
overglaze enamels, 47.8 × 15 × 15cm
(18¾ × 6 × 6in). Brighton, Royal
Pavilion Art Gallery and Museums

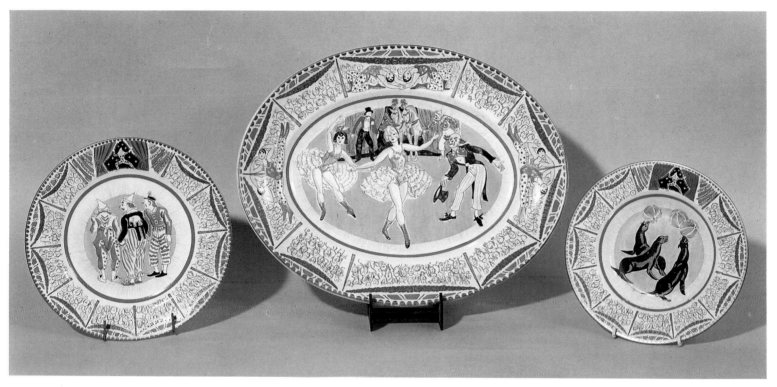

61. Some pieces from *The Circus Dinner Service*. 1934. Clarice Cliff. Decorated with transfer-printed views of circus life by Dame Laura Knight. On loan to the Plymouth City Museum and Art Gallery

Another *Studio* article on painters of the circus recorded that Laura had painted more pictures of the circus than anyone else, and she is often remembered in the popular imagination as primarily a painter of the circus. For this she was greatly admired and loved by circus performers and by the British public alike. The critics, however, thought otherwise, and her exhibition entitled 'Circus Folk', held at the Alpine Club Gallery in 1930, was severely criticized by Herbert Furst writing in *Apollo*. Furst said that Laura reminded him of the 'strong man' in the circus and went on to observe that she

> was rapidly over-developing the muscles of her vision at the expense of her nerves. Her eyes grapple with her subject and hold them in a kind of iron embrace, nor does she let them go until she has all but transferred them to her canvas . . . So that after a visit to this exhibition you really know all there is to be known and more than you want to know about 'circus folk', all with one exception: illusion . . .

He did admire her 'good, hard, solid knowledge and craftsmanship', but regretted that they were all sacrificed to an unattainable ideal, 'the Truth, the whole Truth and nothing but The Truth. Yet every artist should know it is his or her duty to be a splendid liar!'

Laura also experimented with glass and ceramics in the 1930s, but again came in for heavy criticism, this time from a fellow artist, Eric Ravilious. Both artists had designed some coronation ware for Wedgwood in 1937 and Ravilious was annoyed that some of his designs had been considered 'above the heads of the public'. He went on:

> The Coronation mug will be produced which is something; but you should see the one Laura Knight has designed – bloody beyond description – the Wedgwoods say how bad the thing is but point out how big the sales will be – I wish her well but it seems a pity.

Other ceramic designs have more charm (Pl. 60). In 1932–4 the designer Clarice Cliff was involved in an experiment to bring about more contact between living artists and industry, and Laura was one of many artists chosen to decorate tableware. The firms taking part were A. J. Wilkinson (earthenware), E. Brain & Co. (bone china) and Stuart and Sons (glass). Laura produced her famous 'Circus Dinner Service' in conjunction with A. J. Wilkinson. The pieces were decorated with scenes from the circus, ranging from three acrobats inside a border of the crowd, with a clown opening the curtains, to a horse and trainer, a dancing bear, a girl on horseback and Paris the lion, with Togare, his trainer. During an exhibition of the work held at Harrods and entitled 'Modern Art for the Table', Gracie Fields bought a twelve-piece set for £70. This same dinner service was later donated to Plymouth City Museum & Art Gallery (Pl. 61).

Perhaps more so than with her other subject-matter, in Laura's work at the circus, art and life became inextricably confused. In her pursuance of an exciting life she became so totally involved that she often lost sight of her own direction. This occasioned the severe criticisms of some of her circus paintings.

In contrast to her circus subjects, her treatment of more 'ordinary' subjects, such as interiors and views of London, came in for praise. She had painted a series of women in interiors while staying at Mousehole in Cornwall during the 1920s, and one of these, *A Cottage Bedroom* (Pl. 62), was admired by several critics; one stated that it was 'well studied and full of vitality'. Another wrote: 'Laura Knight has apparently lost her heart to Dod Procter's technique but the results certainly justify it. *The Bedroom* is well designed with many points of interest skilfully welded.' It is significant that Laura's work should have been influenced by that of her friend Dod Procter

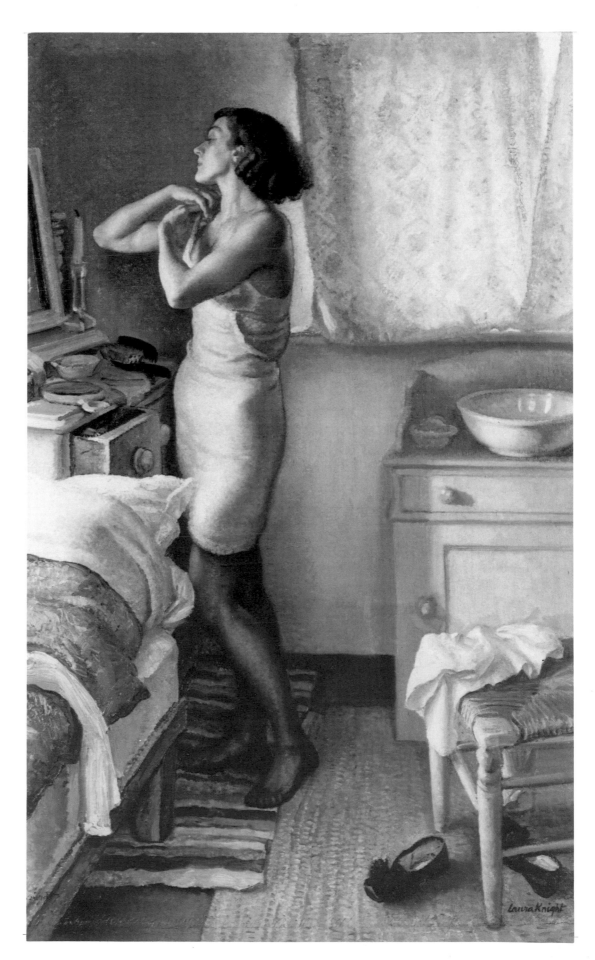

62. *A Cottage Bedroom. c.*1929.
Oil on canvas, 84 × 52cm
(33 × 20½in). Sotheby's

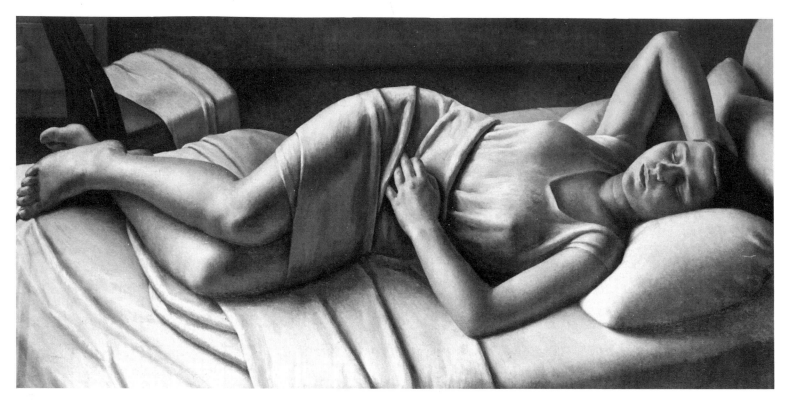

63. Dod Procter: *Morning*. 1926. Oil on canvas, 76.2 × 152.4cm (30 × 60in). London, Tate Gallery

(Pl. 63). Although Laura achieved far more sustained fame and public recognition than Dod, the latter was a much more single-minded artist who was more securely rooted in herself. Dod painted simple subject-matter most of her life, deriving her satisfaction from her own sense of perfection in the use of paint rather than from public acclaim. And Laura, on the rare occasions when she contented herself with a simpler subject, could attain something of her friend's sense of monumentality.

Susie and the Wash-basin (Pl. 64) is another particularly strong work in which Laura has succeeded in capturing the powerful personality of her sitter, and again demonstrates that she was at her best when concentrating on one or two figures. Her portrait of Heather Ealand (Pl. 65), exhibited at the Royal Academy in 1928, is equally strong. It was considered one of the most notable of the Royal Academy exhibits of that year and the model was described in the *Royal Academy Illustrated* as 'a typical finely finished English Girl of today, with her short hair, passion for sport and clear-cut self-reliance'. A model in much demand from Laura and Harold was Eileen Mayo, whose very distinctive features occur in *Blue and Gold* of 1927 (Pl. 66).

Laura painted a number of views of London in both oil and watercolour, many of which are lively and atmospheric (e.g. *The Thames above Chelsea Flour Mills*). *Spring in St John's Wood* of 1933 (Pl. 68) is painted with a freshness and directness that evoke her delight in a sunny but windy day in early spring. The view was taken from her house at 16 Langford Place.

Harold Knight's lack of enthusiasm for the circus and his scorn when Laura attempted unusual subjects are evidence of a very different temperament from hers. He was a quiet reserved man, who did not like being in

64. *Susie and the Wash-basin.* 1929. Oil on canvas, 61 × 61cm (24 × 24in). Preston, Harris Museum and Art Gallery

65. *Heather Ealand*. 1928. Oil on canvas, 55.9 × 45.7cm (22 × 18in). London, Arenski

66. *Blue and Gold*. 1927. Oil on canvas, 50.8 × 45.7cm (20 × 18in). London, Belgrave Gallery

67. Harold Knight: *Portrait of Florence*. 1909/10. Oil on canvas, 159.9 × 120.7cm
(59 × 47½in). Private Collection

the limelight, but in many ways he possessed as strong a personality as his wife. He was a deeply thinking man with strong inner convictions. He suffered for these convictions while in Cornwall during the First World War when, as a conscientious objector, he had to work on the land, and bore much misunderstanding from some fellow artists and the local people. He was also a witty man and on one occasion when Munnings was complaining that 'the bloody fools won't buy my work', Knight rejoined, 'there are plenty of bloody fools who do!'

Although such different personalities, in many ways the Knights complemented each other. Laura loved nothing more than fun and excitement and Harold often acted as a curb on her more elaborate schemes, introducing the cold voice of reason or cutting short her impulsive talk with: 'Now Laura, you know that's a lie!' On the other hand, Laura's enthusiasm and zest for life, although at times irritating to Harold, must also have alleviated the more sombre side of his nature. As we have seen, he did not like Laura's frequent trips away but he never prevented her from going. The couple were probably closest in their later years when Laura did not go away quite so much and they were able to offer each other much warmth and companionship. Their letters written to

68. *Spring in St. John's Wood*. 1933. Oil on canvas, 130.2 × 115.6cm (51¾ × 45½in). Liverpool, Walker Art Gallery

each other while Laura was in Nuremberg, which was the longest time they were ever parted, show a high degree of warmth: 'I am looking forward so much to your return. I don't feel that life is quite normal until you do,' Harold wrote, and: 'It seems strange to be separated from you so completely.' Laura busily replied: 'I only miss my dear one's face. I treat you badly but I love you well.'

As a portrait painter, Harold Knight was able to provide a steady source of income. Some of his works from the Cornish and early London years are particularly fine, especially two portraits of Munnings' first wife, Florence, both in private collections (Pl. 67), and an exceptional interior, entitled *In the Studio* (also in a private collection). In his best work he achieved great subtlety of expression. However, he was not nearly as prolific as Laura, nor was he able to match the tremendous variety of her subject-matter. He inevitably found it difficult to cope with her success and jealousy may have been the reason why it was Barry Jackson and not Harold Knight who took Laura to receive her DBE in 1929. No one was probably as aware of this as Laura herself. She wrote after his death: 'He was a wonderful man. But one makes a husband unhappy as well you know. He was a much greater artist than I was. I felt I stole his thunder being a woman. It gave me a pull. It was rare for a woman to give up her life for painting.' This praise for his work was not an affectation, for she was overheard by one of her family saying in regard to a portrait of Harold's: 'My God I wish I could paint like that!'

5

London: The Gypsies and the Malvern Festival

'I look back to those days when I was accepted as one of themselves by the gypsies at Iver. It was one of the most inspiring times of my working life.'

After a series of disasters including a bad fire and the collapse of the big top under a weight of snow, Carmo was eventually forced to close down his circus. Laura was once more looking for new subject-matter and her old friend Munnings suggested that she painted the races at Epsom: 'Just the sort of thing to suit you . . . come with Violet and me . . . I'll show you around.' Although she did not go with the Munningses on that occasion, she did go later on with her circus friends, Joe and Ally Bert, and was soon painting not only the crowds watching the races (Pls. 71 and 72) but also the gypsies who used to go round telling fortunes.

When Joe died, Ally still accompanied Laura on her expeditions to the races, proving an essential companion. It was through her that Laura came in contact with the owner of a Rolls Royce, Mr Sully, who had taken Joe's coffin to the grave. The Rolls Royce was used for taking bridal parties to church at weekends and Laura suggested that during the week Mr Sully might take Ally and herself to the races – a suggestion with which he seemed happy to comply. The great advantage of the Rolls was its height which enabled Laura to set up her easel and canvas of up to 30 × 25 inches inside (Pl. 75), thus allowing her to paint in some degree of comfort away from the elements.

Dressing up for the races was not a monopoly of the upper classes. The gypsies too wore very colourful silks and satins with equally colourful scarves on their heads over their elaborate hair-dos. They used to pose in the doorway of the Rolls, enabling Laura to feature them with a glimpse of the crowds beyond. Although painted in some haste *Romanies at Epsom* (Pl. 69), *Gaudy Beggars* (Pl. 70) and *Ascot Finery* (Pl. 73) are extremely lively and evocative.

At Epsom, Laura became friendly with an elderly gypsy woman known as 'Granny Smith', who invited her to visit their camp. From then on, Laura and Ally used to set off regularly every weekday, with Mr Sully at the wheel of his Rolls Royce, to the gypsy camp at Iver, where they often stayed until it was quite dark. The gypsies were happy to pose for Laura and she was able to produce a number of extremely sensitive portraits as a result (Pl. 74). Perhaps one of the most outstanding is the painting of the old gypsy granny wearing all her best clothes, entitled *Gypsy Splendour* (Pl. 77). Her vigorous but sensitive handling of paint has lent itself particularly well to portraying this wrinkled but impressive old lady. One feels that whatever blows life has dealt her, including her broken nose (as she told Laura: 'It was me 'usband, twice!'), nothing will disturb her dignified calm.

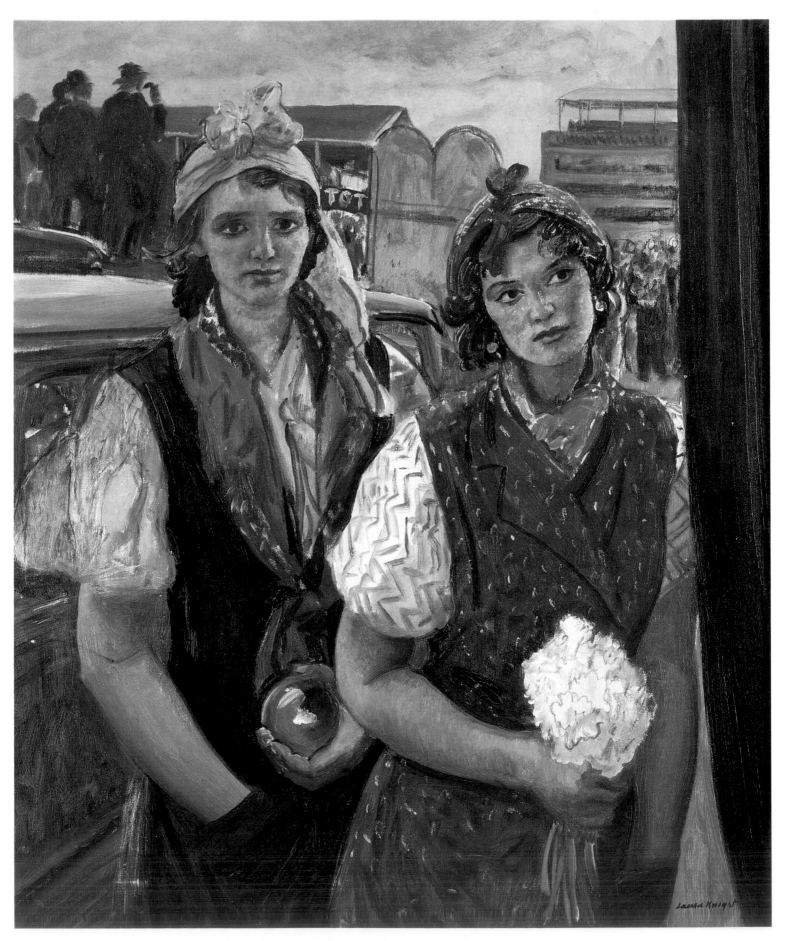

69. *Romanies at Epsom. c.* 1938. Oil on canvas, 76 × 63.5cm (30 × 25 in). Sotheby's

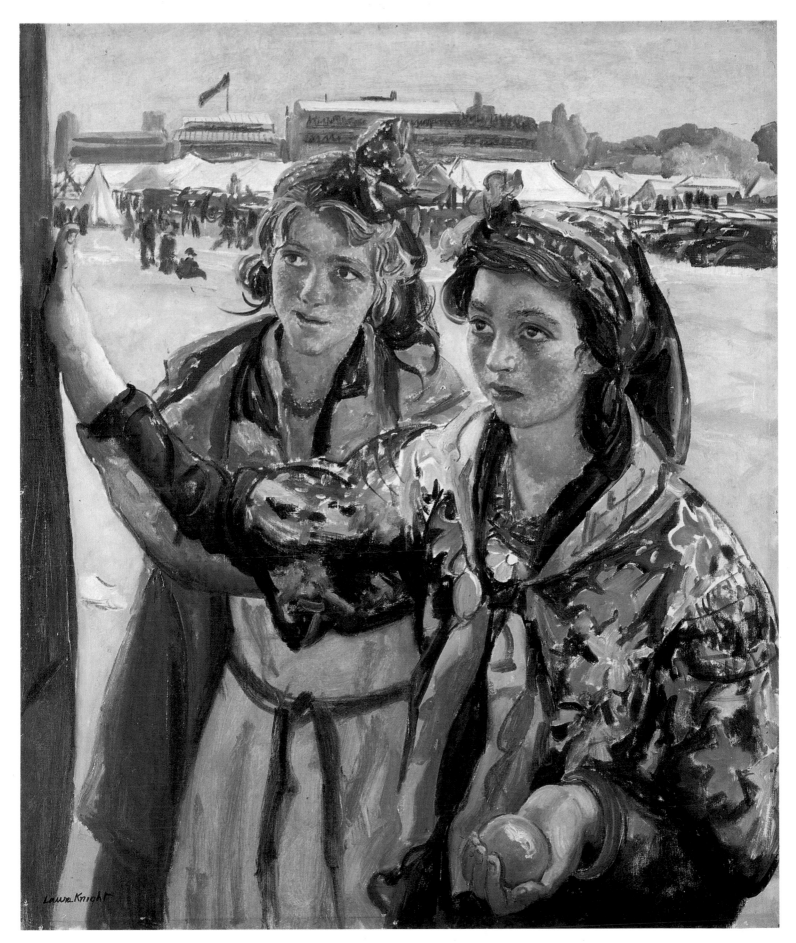

70. *Gaudy Beggars*. 1938. Oil on canvas, 76.5 × 63.9cm (30 × 25in). Aberdeen Art Gallery and Museums

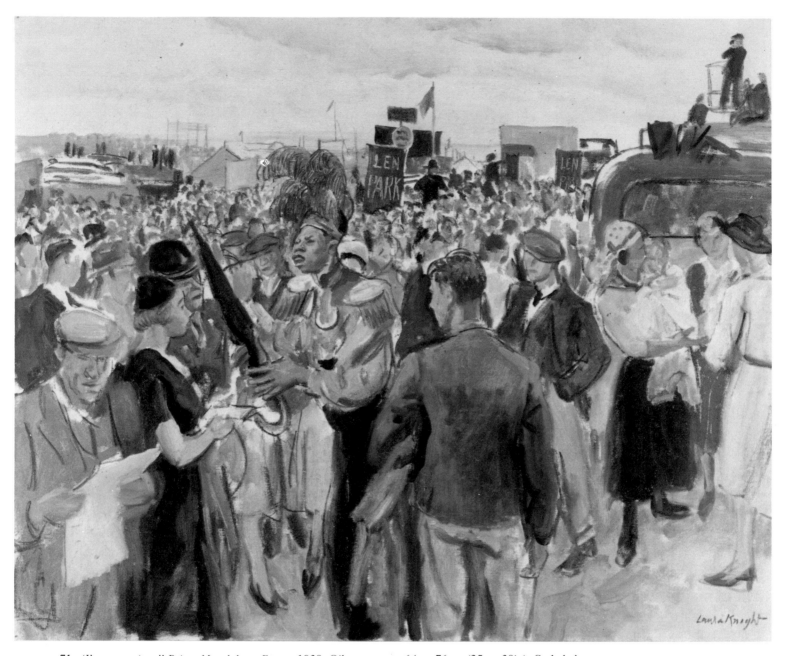

71. *'I've got an 'orse!' Prince Monolulu at Epsom.* 1938. Oil on canvas, 64 × 76cm (25 × 30in). Sotheby's

Laura was particularly drawn to a young gypsy woman called Beulah, whose sad but mysterious face seems to have a story to tell. Although she never heard the story, she has succeeded in expressing this aura of mystery in her portraits of Beulah as well as showing off her lovely jet black hair to advantage (Pl. 78). Laura also greatly enjoyed painting the gypsy children who feature in some of her paintings (Pl. 81).

Perhaps because she was able to concentrate on painting one or two individuals and spend considerably more time on the sittings, Laura's paintings of the gypsies are on the whole far more interesting and satisfactory than her circus work.

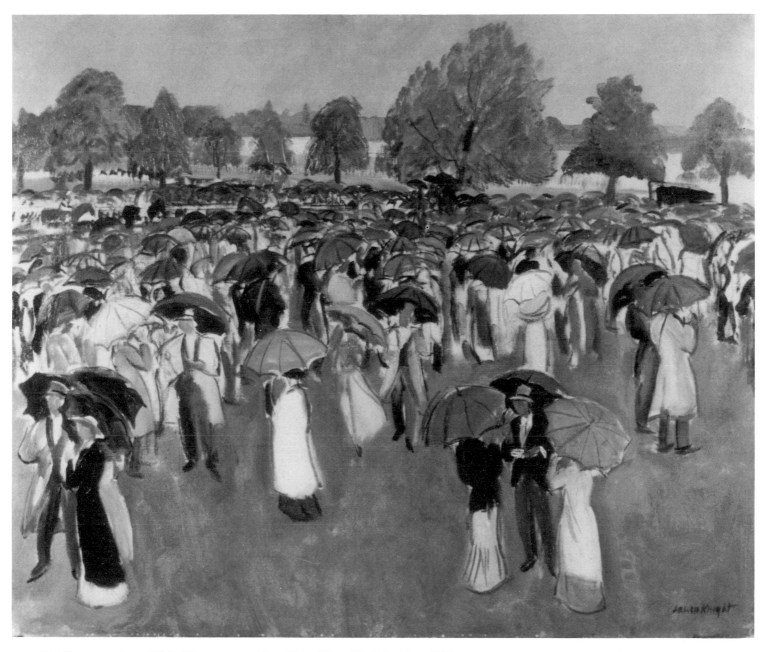

72. *Showers at Ascot*. 1936. Oil on canvas, 64 × 76cm (25 × 30in). London, Phillips

From the late 1920s, the Knights were regular visitors to the Malvern Festival which was organized by their old friend Barry Jackson. They used to stay at Lawnside School where he housed his many guests – authors, playwrights and many other famous people (Pl. 76), including John Drinkwater, Daisy Kennedy, Hugh Walpole and Irene Vanbrugh.

It was through Barry Jackson that Laura first met George Bernard Shaw. When they were introduced Shaw greeted her absently, only to return a little later full of smiles: 'O you are Laura Knight. I did not know that. Scott just said "Mrs Knight"; you might have been any Mrs Knight!' Despite this inauspicious beginning, Laura

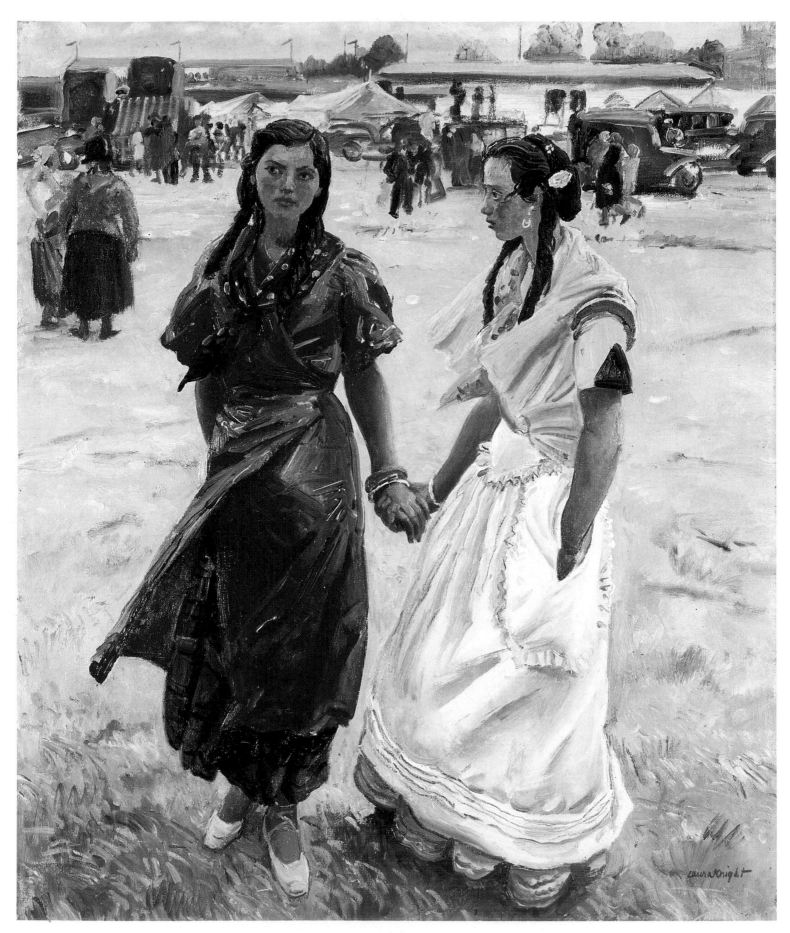

73. *Ascot Finery*.1936–8. Oil on canvas, 76.2 × 63.5cm (30 × 25in). Dundee Art Galleries and Museums

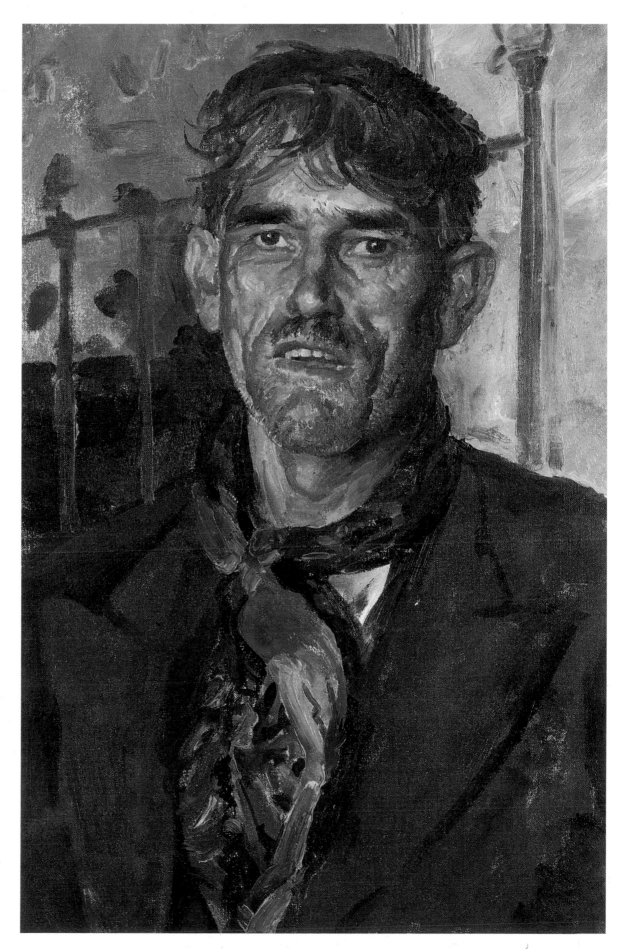

74. *A Gypsy*. 1938–9.
Oil on canvas,
61 × 40cm (24 × 16in).
London, Tate Gallery

and Shaw became friends and used to meet annually at Malvern where Shaw's plays were often performed. It was only after complaints from Shaw that she had never asked him to pose for her that Laura set about painting his portrait. She had to share her model with a Hungarian professor who was making a bust of him at the same time and there was some friction between the two artists. Laura wanted Shaw to stay still while the professor wanted him to move so that he could be viewed from all angles. Shaw himself was unable to understand why Laura could not complete his portrait after one sitting, although he obligingly gave her several more after the sculptor had departed.

The sittings proved quite entertaining for Laura because Shaw used to recite poetry or sing through an entire opera score. Despite these distractions, Laura has succeeded in capturing something of his lively temperament in the finished portrait (Pl. 82), although perhaps she has made him look just a little too innocent and benign. Shaw himself seemed to have been pleased for he wrote to the Curator of Hereford Museum in 1942, to whom the work was later presented, saying that he could not desire more distinguished company in the gallery than that of his old friend Dame Laura Knight. The Knights continued to see a great deal of the Shaws during their visits to Malvern and through them met Lawrence of Arabia, who came with Shaw on one occasion and was mysteriously introduced as 'another Mr Shaw'.

75. Laura Knight painting at Ascot in Mr Sully's Rolls Royce, Derby Day, 1936. Photograph. Nottinghamshire Record Office

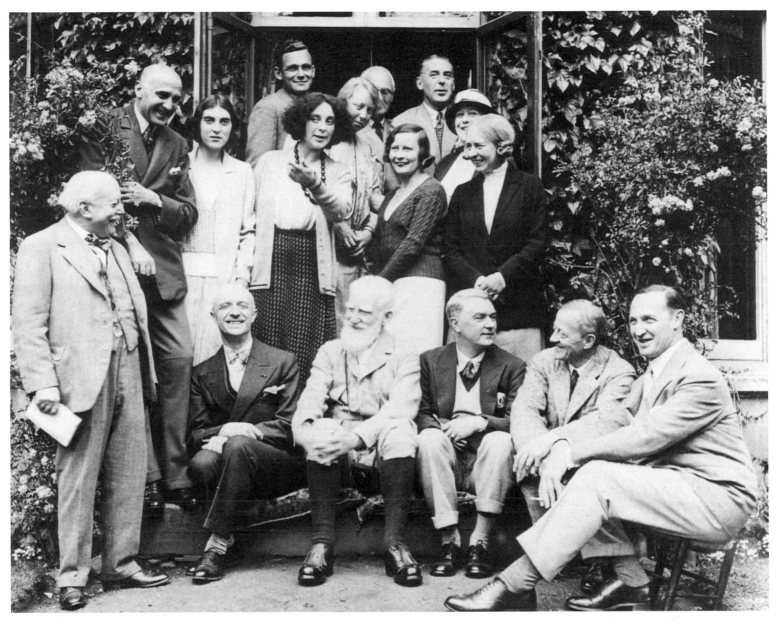

76. Barry Jackson and House Party at Malvern. Mid–1930s. Guests include: Harold Knight (third row, centre, half hidden), Laura Knight (middle row, first right), Bernard Shaw and John Drinkwater, with Barry Jackson (front row, fourth, third and first from right). Photograph. Nottinghamshire Record Office

In 1935 Laura hurt her foot and, resourceful as ever, decided to make use of her enforced rest to write her autobiography. *Oil Paint and Grease Paint* was published the following year and gives an interesting account of her life from the early years in Nottingham right through to the Malvern Festival and the gypsies. Laura's writing is as descriptive as her painting and the book is extremely readable and did more than anything else to increase her popularity with ordinary people. She was, however, criticized in the *Times Literary Supplement* for the fact that all her struggles had been external ones – concerned with the technical side of her art and with material circumstances – rather than an inner *Angst*. The article continued:

This leaves the impression that Dame Laura Knight has never suffered the self-mistrust and misgivings which afflict many if not most artists ... While this undoubtedly accounts for some lack of sensitiveness in

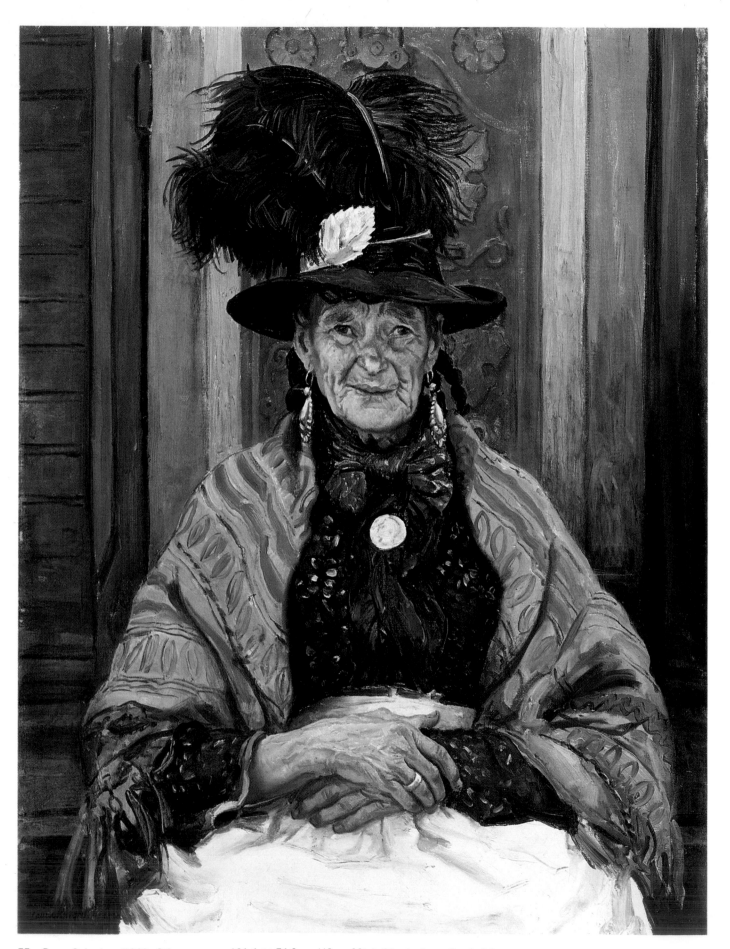

77. *Gypsy Splendour*. 1939. Oil on canvas, 101.6 × 76.2cm (40 × 30in). Nottingham Castle Museum

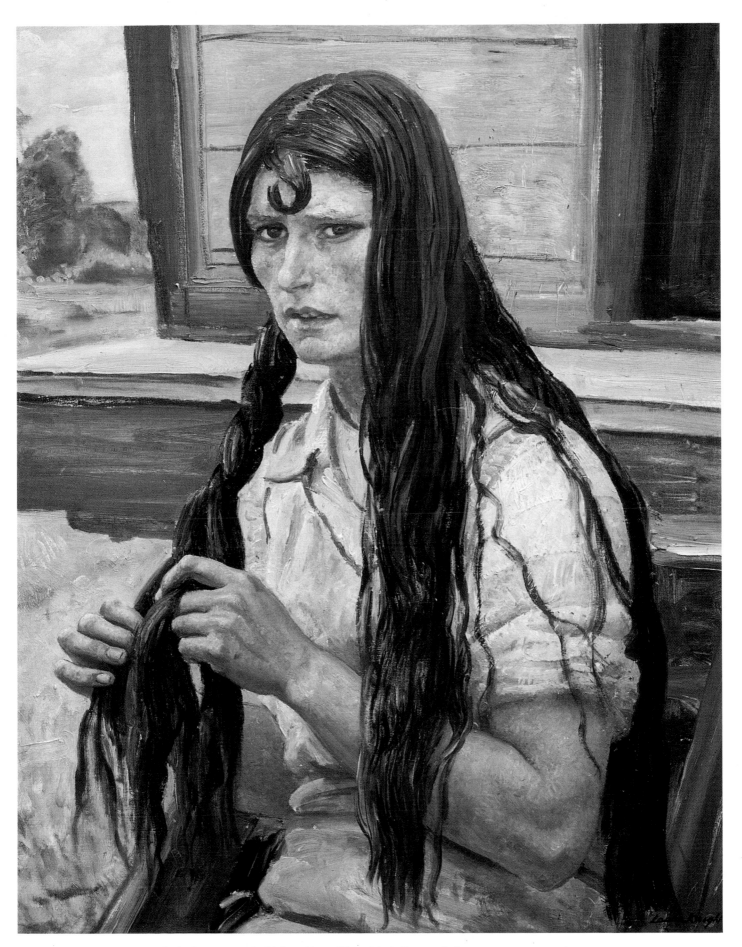

78. *Gypsy plaiting her Hair*. 1940. Oil on canvas, 73.7 × 61cm (29 × 24in). Private Collection

her work, it makes Dame Laura Knight a good companion in her autobiography. In writing as in painting, she is for the frontal attack, with little care for connexions . . .

It is perfectly true that Laura appeared to go through very little internal upheaval on account of her art and this makes her less interesting in a century concerned with inner struggle. She did not attempt to express deep convictions nor did she show a particular social awareness in her art. Her naturally extrovert personality and love of being in the limelight did not allow of much inner searching, and anxieties about money and memories of a childhood of deprivation and struggle forced her to press on in ways which she knew were successful. Thus she could never plumb the depths nor achieve the inner harmony of such artists as Anne Redpath, Mary Potter, Winifred Nicholson and Gwen John. But having stated this, it must be remembered that apart from Gwen John, whose contribution was more fully recognized after her death, Laura Knight was nearly a generation older than most of these women. As a successful woman artist, she was extremely isolated and very much of a pioneer.

In 1967 she wrote to friends after some of her paintings had not reached their reserve at Sotheby's:

Perhaps I am too conceited to be uncertain that there is enough imagination and power in my work to eventually prove of some worth. Being a woman may have something to do with it. From the start I have had a difficulty in being taken seriously as an artist . . .

79. Augustus John: *The Mumpers* (detail). 1912. Oil on canvas, 2.75 × 5.8m (9 × 19ft). Detroit Institute of Arts

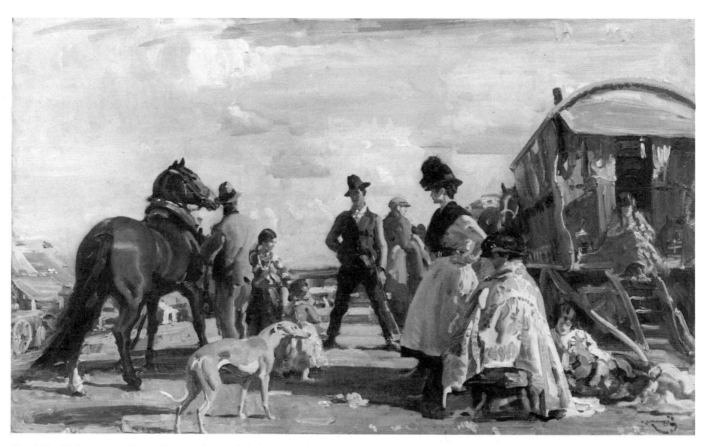

80. Alfred Munnings: *Epsom Downs, City and Suburban Day*. 1919. Oil on canvas, 79.4 × 128.3cm (31¼ × 50½in). London, Tate Gallery

She was very much a product of her artistic background and without doubt belongs to the set of artists who were supporters of the Royal Academy and were seen as very necessary upholders of the traditional technique of painting. She had never been exposed to any form of avant-garde art and tended to mix with academic artists or *plein-air* painters such as the Staithes and Newlyn groups. Even by the time she went to London in 1919, she would probably have seen little work which had not been hung on the walls of the Royal Academy. Her own understanding and interest in more modern forms of painting were never very great. She admitted later in life to finding many modern works 'beyond understanding and mere accidental patterning'.

Alfred Munnings was far more extreme than Laura in his dislike of modern art but in many ways there are strong parallels between their careers (see Pl. 80). Both produced their best work early on, when on the whole they were struggling, and before they had achieved much success. In both cases, success possibly encouraged work which was superficial and lacking the depth and spontaneity of their earlier paintings. They remained good friends throughout their lives, were both very extrovert and both wrote their autobiographies. Laura sometimes tried to intervene for Munnings when he had gone too far in expressing his dislike of contemporary art and appears to have been very tolerant towards him. Munnings, in his turn, was very supportive of Laura and may have been partly responsible for her election as a full member of the Royal Academy in 1935.

Laura was delighted with this appointment and as the only woman member took her duties very seriously.

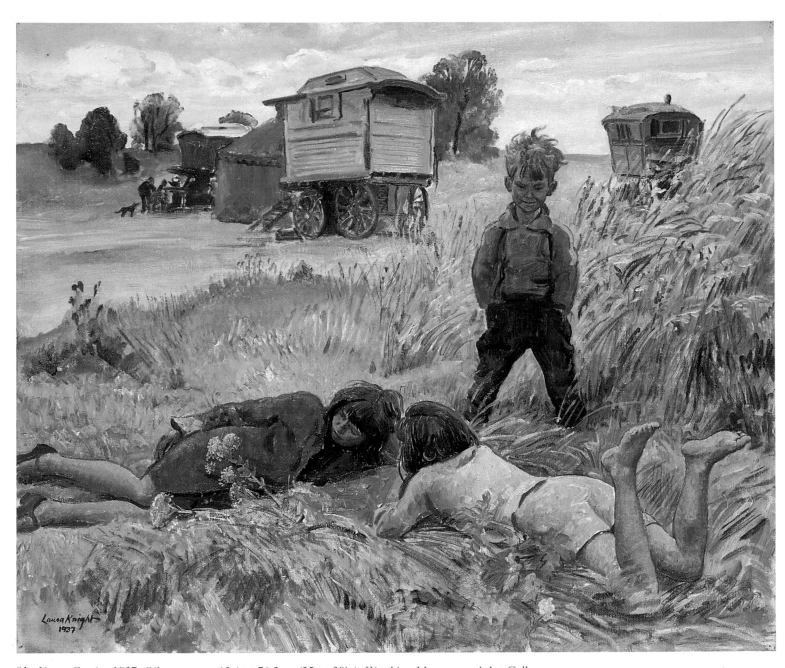

81. *Young Gypsies*. 1937. Oil on canvas, 63.4 × 76.2cm (25 × 30in). Worthing Museum and Art Gallery

82. *Portrait of George Bernard Shaw*. 1933. Oil on canvas, 61 × 50.8cm (24 × 20in). Hereford City Museum

They involved her in serving on the Council for the next two years and inevitably brought her into Royal Academy politics where she was required to take the side of the establishment while also trying to see that justice was done. As an old acquaintance of Augustus John's, she became involved in his row with the Academy in 1935 when he resigned from the Academy in protest against the rejection of Wyndham Lewis' portrait of T. S. Eliot. Laura was given the unenviable task of trying to dissuade him from this course of action. In his stand in favour of modernism, John accused Laura and others of letting the show 'go to pot from year to year', and went on to say that the Royal Academy would always be too slow and too belated to be effectual. At the end of the letter, he praised Laura's recent painting of two Romany girls, perhaps because the subject-matter was close to his own (see Pl. 79). Five years later, John was reinstated at the Royal Academy with the Sovereign's permission.

Laura's membership of the Royal Academy also brought new friendships, such as that with the architect Sir Edwin Lutyens. Neither Laura nor Lutyens had much time for the pomposity which surrounded meetings and dinners at the Academy and preferred to occupy themselves passing absurd notes to each other. This had to come to an end when Lutyens himself was made President. Another President of the Royal Academy with whom Laura worked was Sir William Llewellyn, who never addressed his Council as 'Lady and Gentlemen', since, as he told Laura, she was one of them.

6
The Second World War

*'I look back with horror to those war years. I could make a long list
of factories and workshops where I was employed picturing the
making of instruments to kill: by today's standards they were but
children's toys. But one only wants to forget.'*

The outbreak of the Second World War found the Knights staying at their Colwall hotel near Malvern. They did, in fact, spend most of the war years living there in order to avoid the bombing in London. Harold was particularly happy there and Laura liked to paint in the peace and solace of the Malvern countryside (Pls. 84 and 85) as a respite from her various commissions for the War Office Records. Many of these commissions were large ones, and major tasks for a woman well into her sixties. Undoubtedly, the most important of all, and probably her most important single undertaking ever, was that of representing the Nuremberg War Trials in 1946.

The commissions came through the War Artists Advisory Commission which had been set up in 1939 and was composed of an assortment of artists, art historians and civil servants and chaired by Kenneth Clark, then Director of the National Gallery. A small number of artists received full-time salaries for short periods while others received specific commissions or had their work bought. Many of the artists complained of being kept at a distance from events at the front and instead having to depict the more comfortable side of the war at home. Laura's work tended to be in factories or at RAF stations. Her particular brand of realism and her ability to paint intricate detail made her an obvious choice for subjects which required the accurate depiction of mechanical equipment, and her tremendous stamina permitted her to work in conditions where others might have recoiled. In one factory where she painted, she had to have a shield to protect her canvas from oil and sparks, and her shoes rotted away on the oily floor! The men took on bets that she wouldn't last a day but Laura was so fascinated that she stayed the full six weeks and completed the picture. It is interesting, too, that several of these commissions involved painting women who had excelled in a previously very masculine domain – something with which Laura herself was all too familiar.

The War Artists Advisory Commission first approached Laura to paint scenes of the London Underground but she rejected this offer, partly because Harold was worried about her being exposed to the dangers of bombing. She also felt that she would need an assistant and that the payment offered would not cover this. Instead, she painted three portraits of women military medallists, Corporal Pearson, awarded the Empire Gallantry Medal in 1940 (Pl. 89), Corporal Robbins, and Assistant Section Leaders E. Henderson MN and Sergeant D. Turner (all now in the Imperial War Museum, London). The portrait of Corporal Pearson was painted after

sittings lasting ten days against a background of the Malvern countryside and is perhaps the most relaxed of the three.

For most of her commissions there exists a copious correspondence with the War Artists Advisory Committee's representative, Mr Dickey. Every detail of the transactions is discussed, from framing, glazing and travel expenses to the most important of all, payment. In this area Laura was extremely firm and specific. She refused to paint the three portraits of the women medallists for the 60 guineas offered, saying she would normally receive 500 guineas for the same. A letter between War Office officials refers to her being 'a little difficult'. They decided to offer her 35 guineas per portrait, and to send her a photograph of her previous painting for them 'to soften her up'. The War Office concluded that 'she was not a quick worker but that she was producing some exceedingly popular pictures at a fee which to an artist of her standing was really no more than a token payment!' Laura was exacting about requesting the cost of her materials and on one occasion sent in a bill for forty-two brushes! Despite being considered 'a little difficult' by the War Office, she managed to charm completely one of their officials, Major General Fanshaw, who took her on a short tour of the North of England. He sent a letter back which was full of praise for her.

Laura received 100 guineas for her next commission, entitled *In for Repairs* (Pl. 88), about which she was particularly enthusiastic. It shows some women at work repairing a partly inflated balloon at Wythal near Birmingham. She wrote that 'the balloon posed like a great silver toad with a pulse in its sides', and went on to enthuse over the girls who had posed for her: 'I cannot say too much in praise of all their consideration for me. I worked all Sundays and every other day not to take up too much time.' *In for Repairs* was hung at the Royal Academy in 1941 and caricatured in the *Daily Express* to her apparent amusement.

One of her finest war paintings portrays a similar subject. *A Balloon Site, Coventry* (Pl. 83) of 1943 shows a barrage balloon being hoisted into the air by a team of women with the chimneys of Coventry in the distance. In the middle distance damaged buildings can be seen. The painting was intended as propaganda to recruit 'the right sort of women for Balloon Command' and in her arrangement of the composition and the placing of the women in the foreground, she has succeeded in making this appear both a heroic and a glamorous occupation.

The same year she was commissioned to paint a lady celebrity in the engineering world. Ruby Loftus (Pl. 86) was the first woman in engineering history to tackle the complex machining operation known as the screwing of the Bofors Breech Ring. This was considered one of the most highly skilled jobs in the Royal Ordnance Factory where she worked and one which normally would only be attempted by a man with eight or nine years training. Ruby, at the age of 21, mastered the operation after only a year or two of training.

Because of her expertise, Ruby could not be spared away from the factory and Laura had to go to Newport and paint her at work. The degree of realism and accuracy she achieved is quite remarkable. While Laura could not convey the emotional intensity of war artists such as Paul Nash, with his powerful images of shattered landscapes (e.g. *Totes Meer*), or Henry Moore, with his drawings of the London Underground, she had a particular ability for meticulous and accurate recording of detail. The picture of Ruby was extremely popular in industrial circles and when Ferranti said they would like a colour replica for their Edinburgh works the War Artists Advisory Committee decided to make a poster version of the painting.

Depiction of intricate detail is also a feature of *Take Off* (Pl. 87) painted in 1944 at RAF Mildenhall in East Anglia. Laura chose to paint a Stirling bomber because it was about to be made obsolete and be replaced by the Lancaster. She was given the use of an idle plane to study at leisure before making her painting. Later, she was

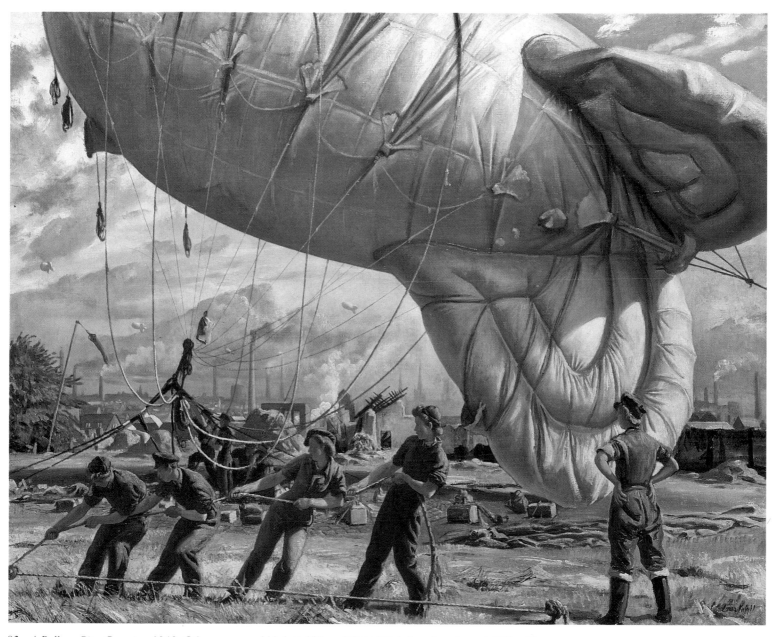

83. *A Balloon Site, Coventry*. 1943. Oil on canvas, 111.6 × 127cm (40 × 50in). London, Imperial War Museum

84. *The Hop Bin. c.*1939. Oil on canvas, 76.2 × 63.5cm (30 × 25in). Sotheby's

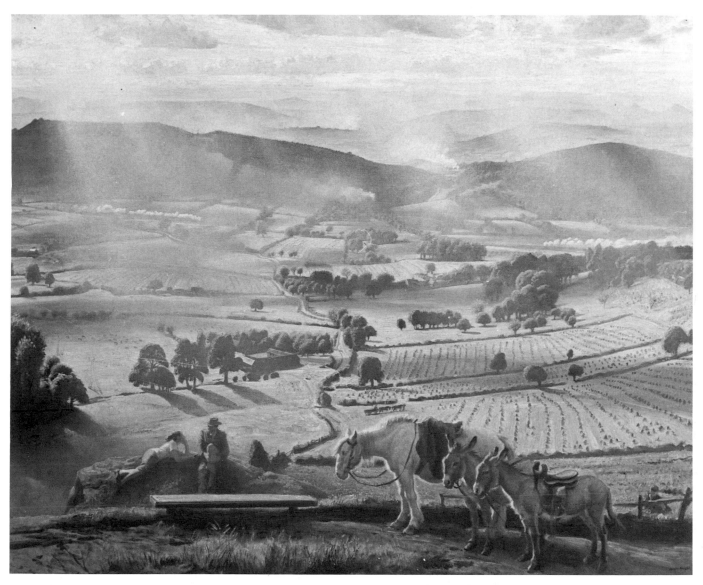

85. *Harvest*. 1939. Oil on canvas, 152.4 × 182.8cm (60 × 72in). Adelaide, Art Gallery of South Australia

able to paint a large clown on the outside of the plane, which then became known as 'The Circus' (Pl. 90). *Take Off* depicts the interior of the bomber with two men in the cockpit and another charting a course. A fourth faces the spectator in the foreground as he turns a knob on a dial. She has succeeded in capturing the look of concentration and strain on his face at this tense moment of take-off. When Laura heard of the death of the navigator who had posed for this work, she was concerned to ensure that his mother should receive a photograph of the painting.

Two further commissions, on Tank Training and the Interrogation of Pilots, were still unfinished when the war ended. The idea then occurred to Laura that instead of these subjects, she might paint the Nuremberg War Trials. The War Artists Advisory Committee agreed to pay for this with the money originally earmarked for the two commissions (500 guineas). She was also to receive third-class travel expenses, a day allowance of six shillings and eight pence and maintenance of a pound a day. Her request to be permitted to represent the War Trials must for ever seem a particularly strange one. It is unlikely that she did it solely for the money, and it was not a subject which would have inspired many artists. Laura probably saw it as a challenge and a unique

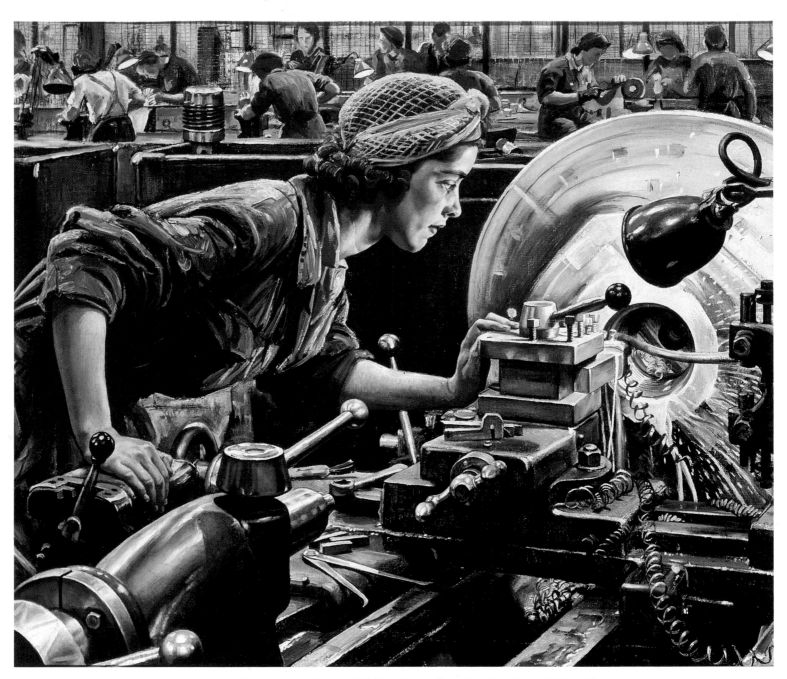

86. *Ruby Loftus screwing a Breech-ring.* 1943. Oil on canvas, 86.4 × 111.6cm (34 × 40in). London, Imperial War Museum

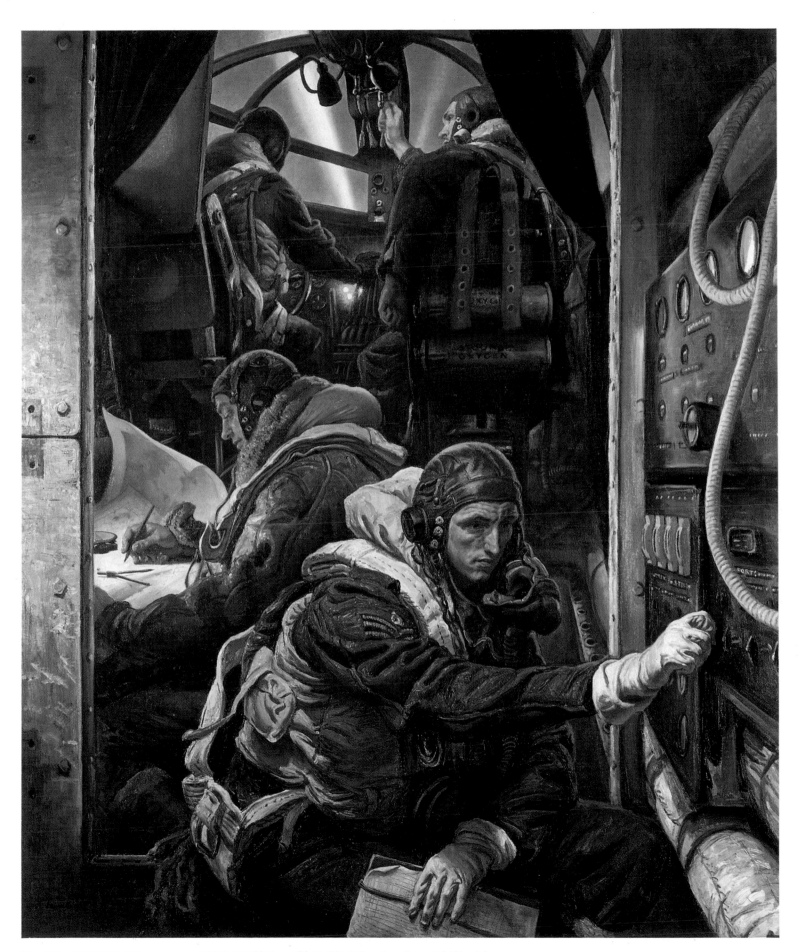

87. *Take-Off*. 1944. Oil on canvas, 182.9 × 152.4cm (72 × 60in). London, Imperial War Museum

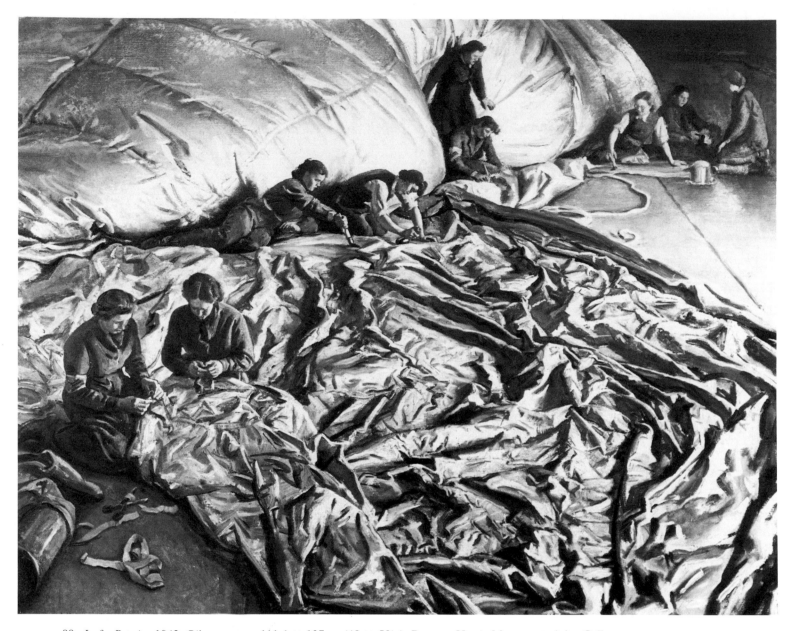

88. *In for Repairs*. 1942. Oil on canvas, 111.6 × 127cm (40 × 50in). Preston, Harris Museum and Art Gallery.

opportunity to be involved in the major historical events of her time at first hand. It might also be seen as an extension of her involvement with Diaghilev's ballet and Barry Jackson's major theatrical productions. It is questionable whether she was fully aware of the scope of her undertaking at Nuremberg. She originally intended to stay a maximum of five weeks, making sketches from which to work when she returned to England. In reality, she was in Nuremberg from the beginning of January to the beginning of April 1946, but was forced through sheer strain to return to England for a break in the middle. She later admitted that she had been so depressed by everything that she found it difficult to eat.

Her diary, which took the form of a regular correspondence with Harold, records very fully all the emotions she experienced while staying in Nuremberg. It gives a fascinating picture of the trial, her work and the people she met while living there. She was deeply moved by the terrible devastation of the city and frequently

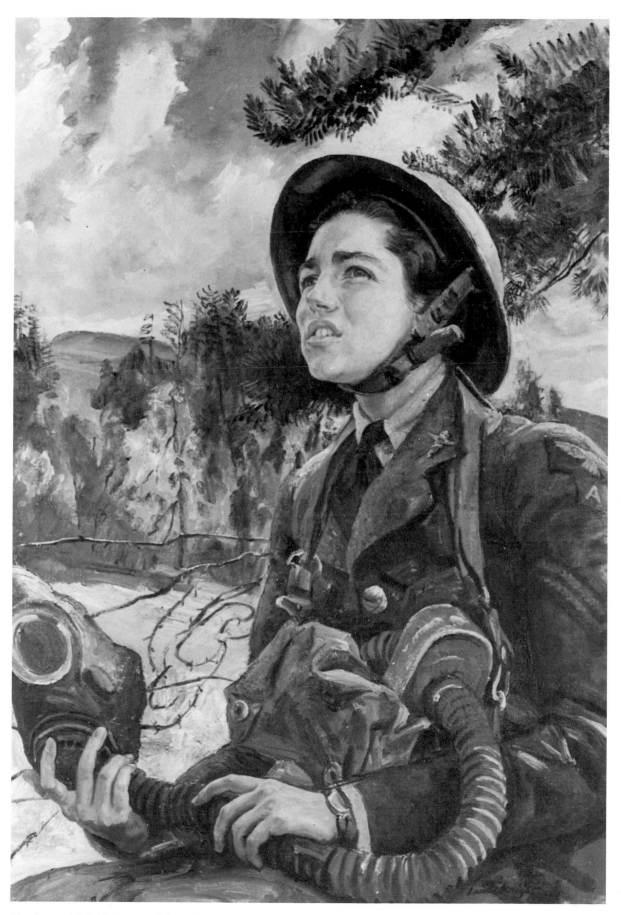

89. *Corporal J.D.M. Pearson GC, WAAF*. Oil on canvas, 91.4 × 61cm (36 × 24in). London, Imperial War Museum

90. Laura Knight painting a clown on an aeroplane at RAF Mildenhall. 1944. Photograph. Private Collection

referred to the continually repeated phrase 'alles kaputt' which she heard from everyone she met there. She was also very aware of the appalling living conditions of those left in the city struggling to keep alive in holes under the rubble, searching for firewood to keep warm in temperatures of many degrees below zero and queueing for hours for bread. She describes this besides the luxurious conditions experienced by those involved with the trial, who were all staying in the same hotel.

Laura met many members of the military and the press while in Nuremberg and was persuaded on one occasion to talk about her experiences in the city on the BBC. She also made friends with one of the Justices conducting the trial, Sir Norman Birketts, and his family, and with Colonel Andrus, the gaoler, with whom she dined on several occasions. On one of these evenings dinner was followed by a visit to *Cavalliera Rusticana* at the Opera House when the entire company sat in Hitler's box. Peter Casson, the young major who was given special responsibility for Laura, was destined to become one of her closest friends – a friendship which lasted for the rest of her life. Laura even managed to be on friendly terms with the 'Snowdrops', the American army police named after their cup-shaped white helmets, who were on guard at the trial.

Most of the other war artists in Nuremberg had to sit in the balcony and sketch using opera glasses. This

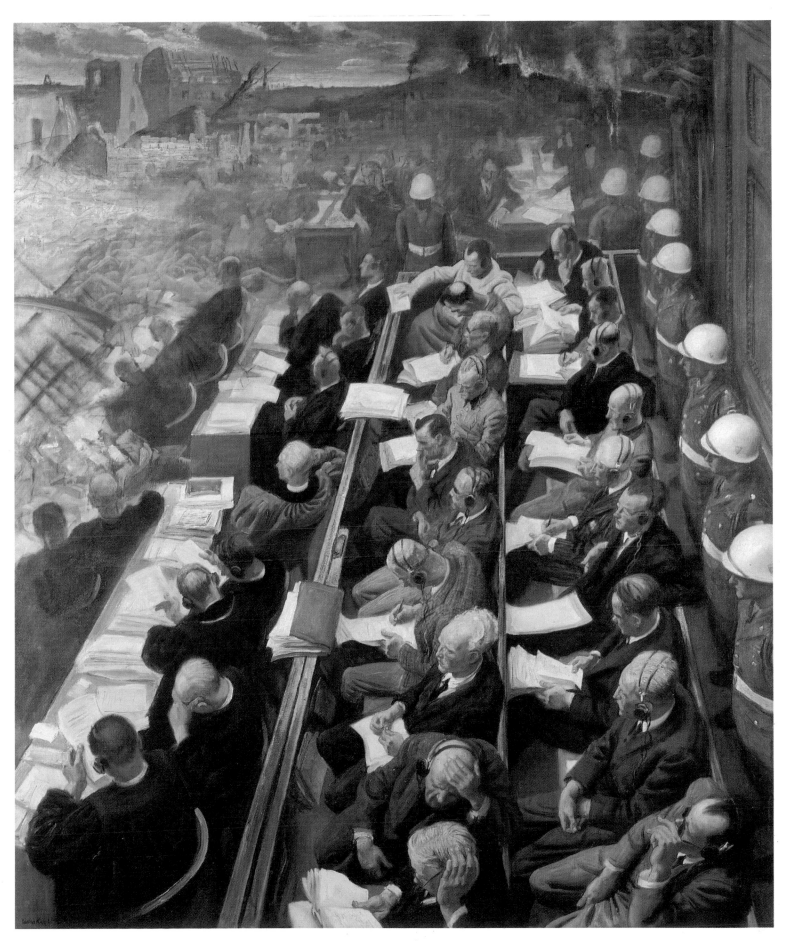

91. *The Dock, Nuremberg*. 1946. Oil on canvas, 177.8 × 152.4cm (70 × 60in). London, Imperial War Museum

92. Laura Knight sketching in her box at the Nuremberg War Trials.
1946. Photograph. Nottinghamshire Record Office

Laura refused to do and instead chose to work in an empty broadcasting box belonging to the Americans (Pl. 92). The box was to prove a source of contention when the Americans wanted it back for a brief while, and in the words of the Lord Chief Justice, 'Laura distinguished herself by becoming an international situation at Nuremberg!' She was later given a large room in the court-house with her name on it, although most of the initial drawings were completed in the box (Pl. 93). From the box she could look down on the whole proceedings with the prisoners only a few arms' lengths away. She could also cut herself off from the trial and work without hearing what was going on. She actually compared it to being in a theatre watching a performance with the prisoners 'like pawns in a losing game'. She referred to the outstanding summing up by Maxwell Fyfe: 'Again and again, the theatre comes to mind: "good lines", "bad lines", "good diction", "bad diction".' She wrote that she felt ruthless at being able to concentrate on the aesthetics of picture-making while twenty men sat below on trial for their lives. She was also sensitive to the fact that the prisoners might not want to be drawn, until assured otherwise.

Towards the end of the diary she admitted to finding her first few days in Nuremberg somewhat desperate, trying things out in pencil on a small scale and unsure how they would work out. She did many drawings of the courtroom, the individual prisoners and members of the counsel with the intention of producing

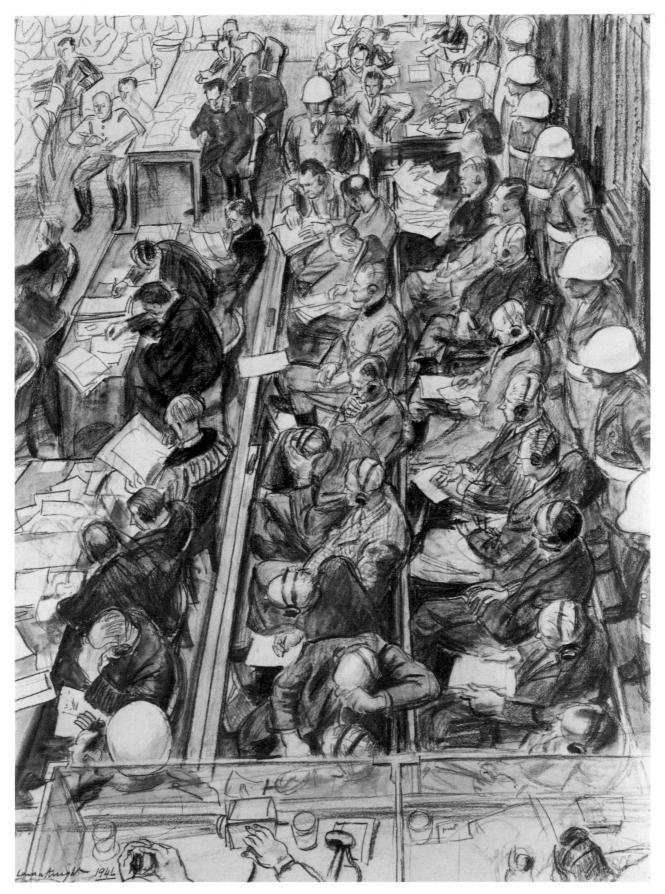

93. Drawing of *The Dock at Nuremberg* (Sketch for the Nuremberg War Trials). 1946. Chalk
and wash, 78.8 × 57.2cm (31 × 22½in). London, Imperial War Museum

the final work when she returned to England. Half-way through she decided to paint the whole work in Nuremberg. She began with a red 'lay-in' and then continued to paint in the same way as she had done when painting the circus or the gypsies, painting each stroke with the intention of it being the last; in her words 'finishing it as she went'. She found it necessary to work this way because her canvas was so fine that she could not afford to build up many layers of paint. She added: 'I felt right on the dot, working with absolute concentration.'

In the finished painting (Pl. 91) Laura tried to convey her own emotions about the trial and about the ruined city which moved her so strongly. She felt that a simple statement of events was not enough:

I do hope I am not being too certain about it; anyway whatever its demerits, it in no way resembles the usual historical or Frank Salisbury picture one dreaded so much. Technically, I have tried to lay it out by suggestion rather than realism.

The combination of the crowded courtroom and the two rows of prisoners, counsel in front and the row of Snowdrops behind, with the visions of devastation, fires, ruined buildings and piles of bodies is an unusual concept. On the one hand the prisoners have all been carefully and individually portrayed, matching so well the verbal descriptions of her diary, which is almost pictorial in itself:

Hess who sits next to him looks mad as a hatter and so very ill – thin as a lath and dark green in colour – a contrast to Goering's pink and white complexion . . . and poor Funk, who to judge from his looks is a Jew, sits fidgetting from huddle to huddle, a pathetic and very small lump of humanity, all the muscles of his face sagging with misery – even his clothes express misery, black, crumpled, in deep folds as he crouches.

On the other, there is the mirage of the devastated city through which she passed every day on the way to the court. She felt that as well as suggesting a reason for the defendants being in the dock it also relieved the monotony.

It is probable that the Nuremberg War Trials moved Laura more deeply than any other event of her life. In her humanity, she felt a need to transcend external reality. She was not used to expressing herself in this way and the result is not altogether harmonious. Nonetheless, it may be seen as a rare attempt on her part to blend realism and fantasy, and convey something more than mere verisimilitude.

In January 1946 she wrote to Harold from Nuremberg: 'Such an extraordinary event in my life, I am beginning to long for the time to arrive when I have done my work here and can be back with you Harold in England.' She was indeed extremely happy to return to the peace and quiet of Harold's company and the Malvern countryside. She had witnessed history in the making and met some of the most brilliant members of the British legal system and of the military for, as she wrote, everyone in Nuremberg was specially picked. Nuremberg may be seen as the peak of her desire for adventure in her continual quest for the new and interesting. She had, however, experienced more than she had bargained for there and was content from then on to lead a much quieter life. She spent much more time with Harold who was now beginning to feel his age and was suffering from arthritis, with only occasional forays to the theatre and the ballet in her latter years.

7

Her Last Years

*'But I can't stop trying to paint different types of things, nor can I
ever stop working.'*

Although they kept their studios in Malvern, the Knights returned to London after the war to resume life as far as possible as before. Laura returned to the familiar themes of the ballet, the circus and the gypsies – often working from earlier sketches. She never gave up painting and was still exhibiting at the Royal Academy in 1970, the year of her death. Her persistence is tellingly conveyed in the words of the daily help from their hotel in Colwall, who told Laura: 'Me and you's the same – we keeps on goin' on – that's our secret!'

Laura painted very few landscapes in her life and when in Cornwall had preferred to paint figures against a background of the sea. The countryside around Malvern provided her with a unique opportunity for painting extensive views of farms and fields with the Malvern hills looming in the distance (Pl. 94). One year she painted a number of watercolours of the autumn mists but again, most of her larger oils include figures or animals. A favourite animal was an old pony called Kitty who with some donkeys used to take parties of children to the top of the hills during the summer holidays. Kitty features in *Harvest* of 1939 (see Pl. 85) and also in *The Hill Mokes* (Pl. 95) and *Kitty and the Donkeys* of 1955. *Harvest* displays the glow of a warm summer's day with an extensive landscape and the smoke of trains and bonfires vanishing into the distance. Since Kitty was described in the 1930s as being 'twenty-one and with teeth too faulty to eat a whole apple', it is probable that in the later works she was painted from earlier sketches.

The Hill Mokes was purchased by a Mrs Averill who had also bought some of Laura's gypsy and clown paintings. She had the largest collection of paintings by Laura of any single collector and she and her husband became very close friends of the Knights, with whom a warm correspondence existed from the early 1950s. Laura was delighted by their support: 'I cannot possibly ever express to you what joy your appreciation of my work has meant to me. Thank you from the bottom of my heart.'

The Knights used to visit the Averills on their Worcestershire farm, when staying at Colwall, and Laura took a great interest in discussing farming. It had always had a great appeal for her and over the years she had painted a number of farming scenes. During the very cold winter at the beginning of the war she had hired two horses and a plough from a local farmer and despite the near arctic conditions had painted them out of doors in a frozen cherry orchard. She painted other ploughing scenes over the years under less trying conditions and a

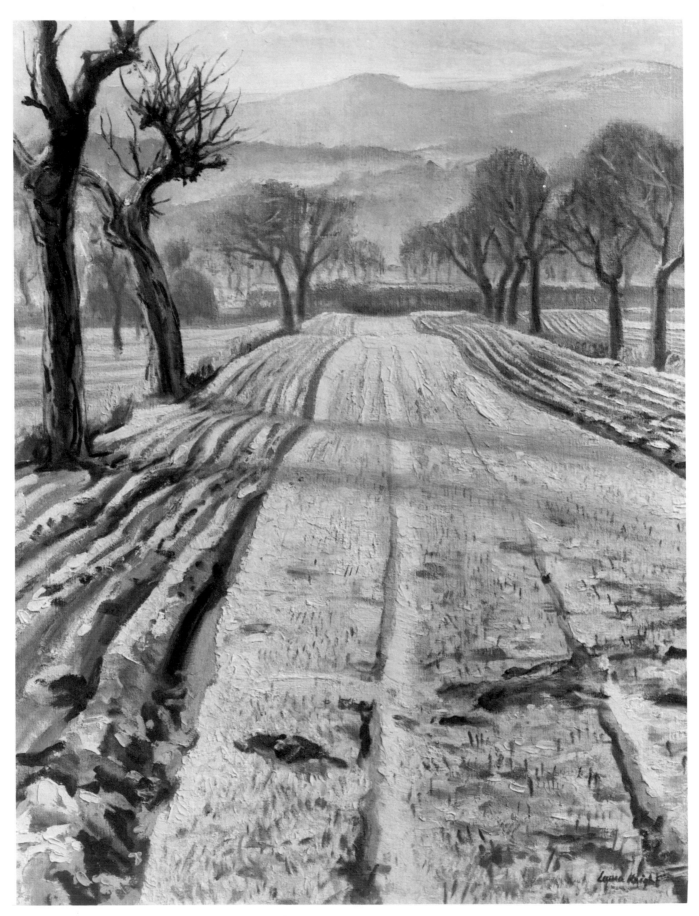

94. *Snow on the Hills*. Oil on canvas. Whereabouts unknown

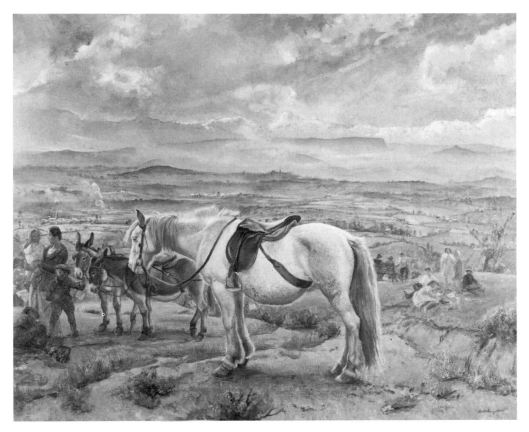

95. *The Hill Mokes*. 1954. Oil on canvas, 124.5 × 155cm (49 × 61in). Private Collection

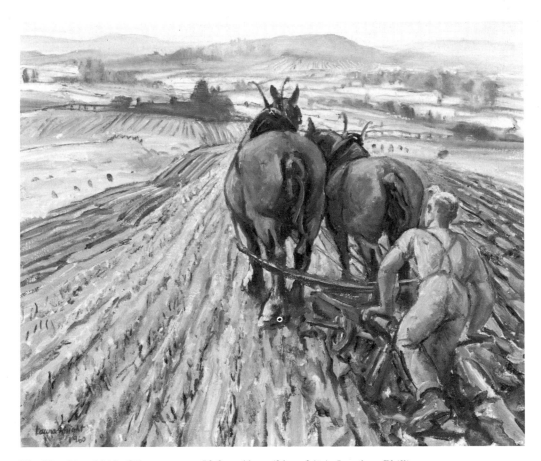

96. *Ploughing*. 1960. Oil on canvas, 53.3 × 61cm (21 × 24in). London, Phillips

drawing of 1954, showing a boy ploughing, was greatly admired by the Averills. She wrote of it: '. . . It was pretty hard work for the lad . . . heavy clay land to say nothing of the horses. I tried to get that look in the drawing.' The ploughing scene of 1960 (Pl. 96) may well be based on this drawing.

In the later 1940s when Barry Jackson was invited to run the theatre at Stratford for a few years, Laura was able to return once more to one of her favourite subjects and also to become involved with making the costumes backstage. In a letter to Jackson of about this time, Laura wrote of her indebtedness to him: he was the person who had taught her 'to appreciate an art' she loved 'so well'. The feelings were obviously mutual and Laura's presence was much appreciated. *The Yellow Dress* (Pl. 97) of 1948 shows the interior of the costume wardrobe at Stratford with a yellow dress hanging on a dummy; it is a vigorous piece of work and again is expressive of her delight in painting behind the scenes. While at Stratford, Jackson commissioned Laura to paint a large watercolour of Paul Scofield, who was then playing Hamlet. Scofield was too busy to pose, so she had to follow him about making numerous quick studies until she had enough from which to paint the portrait.

In 1953 Jackson commissioned her to do some records for him at The Old Vic. The Birmingham Rep was giving some extremely successful performances of Henry VI, Parts I to III, the first time it had been performed since 1906. Laura did a series of lively crayon studies which now adorn the bar of the new Repertory Theatre in Birmingham; *Character in Elaborate Robe* is a particularly strong example (Pl. 98). At 77 years of age, she conceded that she found this harder work than she used to, adding, 'the time comes when one has to pull in a little'.

Laura also did some more work with the ballet and was once again to be found working backstage during rehearsals when Ulanova came to Covent Garden with the Bolshoi Ballet.

It was through Lord Iliffe, whose portrait Harold had painted, that Laura received a commission in 1948 to paint a large picture of the Queen, then Princess Elizabeth. The Princess is depicted holding a pair of scissors having cut a length of ribbon commemorating the newly rebuilt city of Coventry. Behind her are the Mayor and some civic dignitaries and in the distance the cathedral. Laura made several trips to Coventry to paint these dignitaries while the Princess posed for her in one of the upper chambers at Buckingham Palace. After the first sitting Laura wrote that she was thrilled with her subject and that the Princess was happy looking at the crowds outside. At the next sitting, however, the Princess was apparently 'uncomfortable and out of sorts, but stuck it out'. Laura found that she was also affected and painted less well as a result. The finished work was a disappointment both to Laura herself and to the Coventry notables who had hoped to be portrayed with greater individuality. But, without realizing it, Laura had been sickening for an illness for some time and one day when going to her studio had strained her right arm trying to unlock the door, soon losing the use of both arm and shoulder. When the same happened to her left arm, Harold took her to two London doctors who both failed to find the trouble. In desperation he took her to Malvern where the doctor in Colwall, Dr Richardson, diagnosed the problem as due to a blood complaint, and she stayed with the Richardsons while receiving treatment. Later, she said she owed her life to him. True to form, as soon as she was able to hold a brush again in her right hand, she scraped out and almost entirely repainted the Coventry painting. This was not an easy task since her left arm was still out of action and Ally had to hold the palette and brushes for her. Lord Iliffe was very pleased with the final result which for many years hung in his board room and now belongs to the Herbert Art Gallery in Coventry (Pl. 99). Despite her heroic efforts the finished painting is ponderous and dull and came in for some severe criticism when exhibited at the National Portrait Gallery in 1986–7.

In 1961 Harold Knight died. He had been suffering increasingly from arthritis and had not been strong

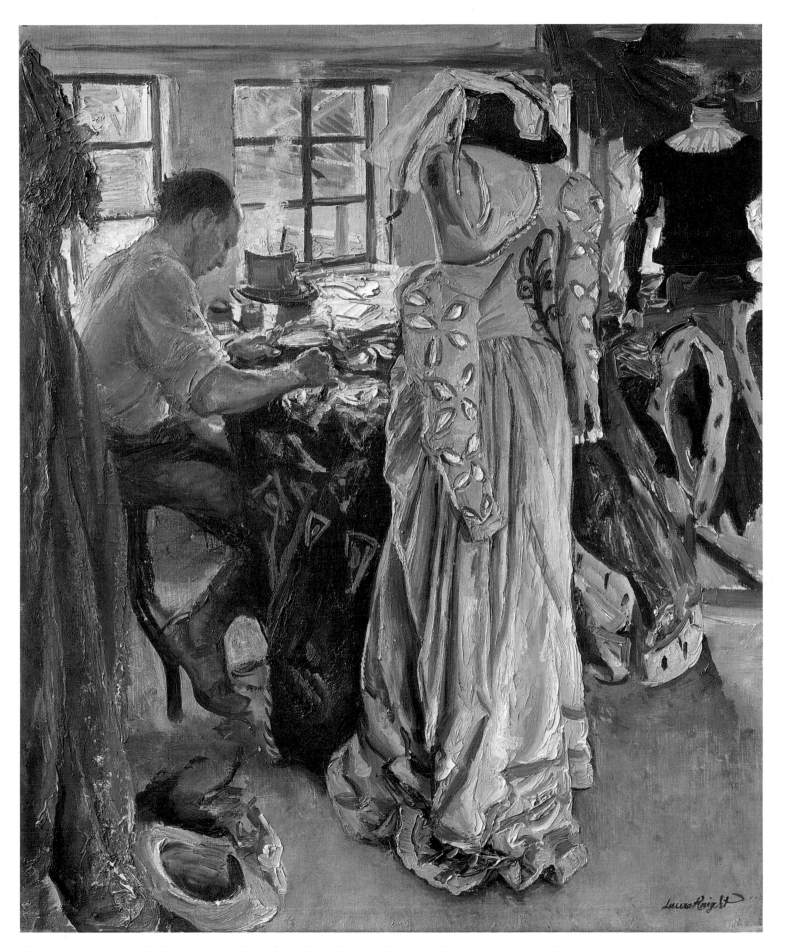

97. *The Yellow Dress*. 1948. Oil on canvas, 77 × 62cm (30⅜ × 24⅛in). Worcester City Museum and Art Gallery

98. *Henry VI: Character in Elaborate Robe. c.*1953. Crayon, 40.6 × 61cm (16 × 24in). Birmingham Repertory Theatre

99. *Princess Elizabeth opening the New Broadgate, Coventry*. 1948. Oil on canvas, 183.5 × 230cm (72¼ × 90½in). Coventry, Herbert Art Gallery

for some time. Laura was naturally very shocked by his death. In a letter to her friends the Averills she wrote: 'I am managing in some measure to keep calm in the knowledge that an unbreakable bond that has existed throughout between Harold and me is still unbroken.' And in an article in the *Woman's Guardian* she acknowledged her debt to him: 'We couldn't have been closer. I didn't feel part of me had died when he died because I feel we are still one . . . still together. He gave me every chance from the word go . . .'

She battled on alone despite advancing years and was just as prolific in her work as before, tending to concentrate on more familiar subject-matter and portraits. She considered nothing kept her as well as plenty of

hard work, although inevitably she became weaker over the years. She entertained with the help of her house-keeper, Miss Worth, opened exhibitions and attended Royal Academy meetings. In 1964 after the Royal Academy had been taken to task for excluding women members from dinners and banquets at Burlington House, Laura, Anne Redpath and Gertrude Hermes were invited to dinner at the Assembly Rooms, thus breaking a masculine tradition of 196 years. Laura proudly informed the assembled company that her great-grandmother had been a staysmaker. 'And there', she said, pointing to one of the royal portraits with which the Assembly Room was hung, 'is Queen Caroline wearing the stays my great-grandmother made for her!'

There were several exhibitions of her work during the 1960s but undoubtedly the most important was her major Royal Academy exhibition held in 1965. She was extremely proud to be accorded this honour and felt that she was in good company following on as she did after exhibitions by Frank Brangwyn, John, Munnings, Gerald Kelly and Russell Flint. Her only disappointment was that Harold Knight was not included. The exhibition was the largest one ever shown of her work, containing over 250 works covering all the periods of her life. Her old friend from Nuremberg days, Peter Casson, gave a select lunch party for her to celebrate the occasion. A photograph of her of about this time shows her unquenchable spirit (Pl. 100).

The exhibition coincided with the publication of her second autobiography, *The Magic of a Line*. This is written more succinctly than *Oil Paint and Grease Paint* and includes another thirty years of her life. She had found writing the first book pretty hard work and Harold had told relations that he felt like 'a squeezed orange' afterwards, but she admitted the second to have been 'a sweat indeed'. She wrote to the Averills: '. . . don't ever let anybody try to write a book if they don't know how – a second book is far harder to do!'

In her letters to the Averills, Laura had expressed fears about how the critics would receive her Royal Academy exhibition. Her fears were justified in part for there were some scathing reviews. A writer in *The Burlington Magazine* seemed to find very little at all to praise in her work: 'The exhibition confirms the general image of Dame Laura Knight as an exponent of a sentimental brand of neo-impressionism with a partiality for scenes of ballet and circus life.' He emphasized her sheer technical facility displayed from an early age but felt that she had remained facile and sentimental. He criticized her inexactitude, her weak sense of colour and added that she had never been able to rid her work of a certain overall vulgarity. He concluded that she lacked finesse, panache, delicacy and imagination and that 'like many artists without a strong imaginative gift, she settled for the downright obvious image of *Dawn*, almost as fatuous as Watts' *Hope*.'

Although there is a measure of truth in this attack, it is far too sweeping. Yes, Laura's work was sometimes facile and sentimental and some of her circus paintings tended towards vulgarity; but no one could describe her watercolours as lacking in delicacy, and her etchings lack neither panache nor imagination. One cannot help thinking that if the reviewer had seen a smaller and more carefully selected exhibition of her work concentrating on her best periods – i.e. Cornwall, Staithes, and the early years in London – he might have been less damning. Other reviewers besides being kinder were also fairer. One said that she belonged to the generation that first broke from Victorian restraints, and observed that her work had a rollicking Edwardian vitality which found its most natural expression in the circus, ballet, gypsy life and race courses. However, he too disliked her nude and allegorical scenes.

Her old friend Adrian Bury, who had written several articles in praise of her over the years, went to the other extreme and described her as one of the greatest artists of this century, adding that it was difficult to think of any living painter whose style was more accomplished and whose versatility more fruitful.

100. Laura Knight, aged 88. Photograph

The last exhibition of her work that Laura was involved with was held, appropriately enough, in her home town of Nottingham in 1970, in the Castle Museum. Sadly, she never lived to see the exhibition as she died the day before it opened, at the age of 93.

Towards the end of *The Magic of a Line*, Laura had suggested that she had tried to achieve too much in too many different media and was in many ways a 'Jack of all trades, master of nix'. She told how one friend had asked her why after the success of her two Newlyn paintings, *The Boys* and *Flying a Kite*, she had not stuck to painting children, adding: 'You'll never go far if you keep on changing your subject.' But Laura felt that it was in her nature to continually want to paint something different. She lacked the single-mindedness of her fellow Newlyn artist, Dod Procter, who painted simple subjects, such as still lifes and figures, with intense concentration and care. For Dod, the fact that her paintings were appreciated by others was a bonus. Laura, on the other hand, who had always admitted to a childish love of showing off, often painted for her audience. Her show of bravado when painting *The Green Feather* is also an indication of a very different approach. Perhaps Laura came closest to Dod's approach with works such as *The Beach*, *The Boys* and *Flying a Kite* and other Cornish works, when she was painting for the sheer joy of it. Later, she seemed to find her satisfaction in attempting more and more unusual and ambitious projects. Not that she should be criticized for undertaking these projects, but rather for allowing them to become all important, so that the act of *painting* came second. It seems that the part of her nature which loved showing off gradually gained the upper hand, perhaps fed by success: external interest and excitement and the need to continually please her audience became more important than exploring her own inner development. Thus her work became harsher and cruder in her later years.

Nevertheless, she had come a long way from her youthful days in Nottingham. She had led an exceptionally varied and colourful life and had produced a vast body of work in a number of different media depicting a wide variety of subjects. She had also written two lively autobiographies. She had been among the first women to become Royal Academicians, as her mother had foretold when she was quite a small child. In the end, one must give this remarkably tireless woman her due for her endurance, her vitality, her courage, her energy and her personality. No other woman artist of her generation, and very few men, achieved anything like the range, diversity and sheer volume of output, and very few, if any, could match the great variety and interest of her extraordinary life.

Bibliography

DAME LAURA KNIGHT: *Oil Paint and Grease Paint*, Ivor Nicholson & Watson, London, 1936

DAME LAURA KNIGHT: *The Magic of a Line*, William Kimber, London, 1965

DAME LAURA KNIGHT: *A Proper Circus Omie*, Peter Davies, London, 1962

JANET DUNBAR (with appendix by David Phillips): *Laura Knight*, William Collins & Co., Glasgow, 1975

Limited Edition Books

Laura Knight: A Book of Drawings, with a foreword by Charles Marriott and descriptive notes, John Lane, The Bodley Head, London, 1923

Modern Masters of Etching: Laura Knight DBE, ARA, introduced by Michael Saloman, The Studio, London, 1932

Articles

NORMAN GARSTIN: 'The Art of Harold and Laura Knight', *Studio*, 57, 1913, pp. 183–95

DAME LAURA KNIGHT, 'An Artist's Experience', *Studio*, 148, 1954, pp. 129–35

Nottingham Record Office has a full copy of Laura Knight's Nuremberg Diary, 1947

The quotations at the beginning of each chapter are taken from Laura Knight's two autobiographies, *Oil Paint and Grease Paint* and *The Magic of a Line*. All quotations from the artist's published and unpublished writings are reproduced by permission of the Estate of Dame Laura Knight.

Photographic Acknowledgements

The paintings of Dame Laura Knight are reproduced by permission of the Estate of Dame Laura Knight. The publishers wish to thank all museums, galleries and others who have contributed towards the reproductions in this book. Further acknowledgement is made to the following: *28* The Principal and Fellows, Newnham College, Cambridge; *17* © Sir Alfred Munnings Art Museum, Dedham; *79* © Detroit Institute of Arts, City of Detroit Purchase; *82* Courtesy Hereford City Museums; *9* Hull City Museums and Art Galleries; *4, 56* Leicestershire Museums, Art Galleries and Records Service; *35, 36* photographs from *Laura Knight: A Book of Drawings* (foreword by Charles Marriott) published by The Bodley Head; *1* © Christie's; *94* photo: Courtauld Institute of Art; *19* Richard Green Gallery; *83, 86, 87, 89, 91, 93* Reproduced by permission of the Trustees of the Imperial War Museum; *18* © Newlyn Orion, Cornwall; *53, 75, 76, 92* Principal Archivist and Staff of the Nottinghamshire Record Office; *7, 64, 88* Reproduced by kind permission of the Harris Museum and Art Gallery, Preston, Lancashire; *33* Left to their niece Judith Hughes; *45* Reproduced by kind permission of the Metropolitan Borough of Sefton Libraries and Arts Services Department; *15, 16, 58, 59* Reproduced by arrangement with the Tyne and Wear Museums Service; *63* © P. Procter; *85* A. R. Ragless Bequest Fund 1956.

List of Plates

Ascot Finery 73
Ballet 37
A Ballet Dancer 38
The Ballet Shoe 42
A Balloon Site, Coventry 83
*The Barretts of Wimpole Street: As seen from the Wings, Queen's
 Theatre* 44
The Beach 16
Lamorna Birch and his Daughters 26
Blue and Gold 66
The Boys 21
'Carnaval' 39
Charivari or *The Grand Parade* 52
Cheyne Walk 32
The Circus Dinner Service 61
The Convalescent – Study for Juanita 50
A Cornfield in Holland 15
Cornwall 25
A Cottage Bedroom 62
A Dancer Resting 36
The Dock, Nuremberg 91
The Dock at Nuremberg (Sketch for the Nuremberg War Trials) 93
Dressing the Children 9
The Dressing-Room 41
A Dressing-Room at Drury Lane 45
Heather Ealand 65
The Elder Sister 8
Elsie on Hassan 54
The Fishing Fleet 13
Flying a Kite 24
Gaudy Beggars 70
Girl's Head 4
Girl playing with a Cat 6
The Green Feather 29
A Gypsy 74
Gypsy plaiting her Hair 78
Gypsy Splendour 77
Harvest 85
Henry VI: Character in Elaborate Robe 98
The Hill Mokes 95
The Hop Bin 84
Portrait of Robert and Eleanor Hughes in an Open Landscape 33
In the Fields 14
In for Repairs 88
'I've got an 'orse!' Prince Monolulu at Epsom 71
The Knitting Lesson 7
Lamorna Cove 30
Lampstand 60
Make-up 43
Man in a Top Hat 3
Mary and the Shetland Ponies 58
The Mirror 10
Mother and Child 5

On the Cliffs 19
Old Time Clowns 55
Anna Pavlova 35
Corporal J. D. M. Pearson GC, WAAF 89
Peeling Potatoes 11
Penzance Fair 23
The Piccaninny 49
Ploughing 96
Plucking the Goose 12
Princess Elizabeth opening the New Broadgate, Coventry 99
Romanies at Epsom 69
Ruby Loftus screwing a Breech-ring 86
Self-Portrait 2
Self-Portrait 51
Self-Portrait with Nude frontispiece
Portrait of George Bernard Shaw 82
Showers at Ascot 72
Snow on the Hills 94
Some Holiday 47
Spanish Dancer, No. 1 46
Spring 27
Spring in St John's Wood 68
Staithes, Yorkshire 1
Susie and the Wash-basin 64
Take-Off 87
The Theatre Dressing-Room 40
Three Clowns 56
Three Graces of the Ballet 48
Two Girls on a Cliff 20
Two Girls by a Jetty 28
Two Girls reading in a Sunlit Garden 34
Two O'Gusts and Two Lions 59
The Yellow Dress 97
Young Gypsies 81
Wind and Sun 31
Zebras 57

STANHOPE FORBES *A Fish Sale on a Cornish Beach* 18
AUGUSTUS JOHN *The Mumpers* (detail) 79
HAROLD KNIGHT *Portrait of Florence* 67
ALFRED MUNNINGS *Epsom Downs, City and Suburban Day* 80
 St Buryan Races 17
DOD PROCTER *Morning* 63

Photographs

Barry Jackson and House Party at Malvern 76
Laura Knight, aged 88 100
Laura Knight at RAF Mildenhall 90
Laura Knight painting at Ascot in Mr Sully's Rolls Royce 75
Laura Knight sketching at the Nuremberg War Trials 92
Dame Laura Knight with clowns and performers 53
Varnishing Day at Newlyn Art Gallery 22

Index

Numbers in italics refer to the illustrations

Alma Tadema, Sir
 Lawrence 17
Andrus, Colonel 110
Armstrong, Elizabeth
 25
Arthur Peter, Uncle
 see Bates, A. P.
Asquith, Mrs 33
Atherly, Major 66
Averill, Mr and Mrs
 115, 118, 121, 122

Baer, Dr 60
Ballets Russes 47
Barbirolli, Sir John 57
Barrett, William 12
Bartlett, Ethel 56–7
Bastien-Lepage, Jules
 17
Bates, A. P. (Uncle
 Arthur Peter) 7, 8,
 12
Bates, Mrs ('Big
 Grandma') 7, 8, 9
Bates, Mrs ('Little
 Grandma') 7, 8
Bax, Arnold 57
Beldon, Eileen 57, *44*
Bert, Ally 68, 85, 118
Bert, Joe 68, 85, *56*
Beulah 88, *78*
'Big Grandma' *see*
 Bates, Mrs
Birch, Lamorna 26,
 34, *26*
Birch, Mrs Lamorna
 (Mouse) 26
Birketts, Sir Norman
 110
Bonner, Barbara 49
Brain, E., & Co. 76
Bramley, Frank 12
Brangwyn, Frank 122
Brown, Ernest 24
Bury, Adrian 122

Carmo 66, 68, 85

Casson, Peter 110,
 122
Cecchetti, Maestro 47
Clark, Kenneth,
 Baron 101
Clausen, George 16
Cliff, Clarice 76, *61*
Cohen, Harriet 57

Davies, Gwen
 Ffrangçon *see*
 Ffrangçon-Davies
Davies, W. H. 56
Degas 48
Diaghilev 47, 57
Dickey, Mr 102
Drinkwater, John 89,
 76

Ealand, Heather 78,
 65
Elizabeth, HM the
 Queen 118, *99*
Everett, John 57

Fanshaw, Major
 General 102
Ffrangçon-Davies,
 Gwen 57, *44*
Fields, Gracie 76
Flint, Russell 122
Forbes, Stanhope 12,
 25, 28, *18*
Foster, Wilson 8–9
Fry, Roger 56
Furst, Herbert 76
Fyfe, Maxwell 112

Gallico, Paul 68
Garstin, Norman 25,
 26
Gertler, Mark 24
Gielgud, Sir John 57
Gore, Spencer 48
Gotch, T. C. 25

Hague School 17

Hardwicke, Cecil 57,
 44
Harvey, Harold and
 Gert 26
Havemeyer, Mrs 57
Henderson, Asst.
 Section Leader E.
 101
Hermes, Gertrude
 122
Hoover, Earl 49
Hopwood, Harry 18
Hughes, Robert and
 Eleanor 40, *33*

Iliffe, Lord 118

Jackson, Sir Barry 57,
 84, 89, 118, *76*
John, Augustus 65,
 100, 122, *79*
John, Gwen 96
Johnson, Charles 7
Johnson, Charlotte 7,
 8, 9
Johnson, Nellie 7
Johnson, Sis 7, 8, 9,
 12

Karsavina 47
Kelly, Gerald 122
Kennedy, Daisy 89
Knight, Edwin 34
Knight, Harold 9, 12,
 18, 24, 26, 34, 44,
 47, 56, 57, 60, 66,
 78, 82, 84, 101,
 114, 115, 118, 121,
 122, *67*
Konody, P. C. 44

Lane, Sir Hugh 33
Langley, Walter 25
La Thangue, Henry
 17
Lawrence of Arabia
 92

Leighton, Frederic,
 Baron 17
Lewis, Wyndham 100
Licette, Miriam 57
'Little Grandma' *see*
 Bates, Mrs
Llewellyn, Sir William
 100
Loftus, Ruby 102, *86*
Lopokova, Lydia 47,
 48, 52
Lutyens, Sir Edwin
 100

Mackie, Charles 12
Marba (the clown) 68,
 56
Mayo, Eileen 78, *66*
Mills, Captain
 Bertram 65
Moore, Henry 102
Munnings, Sir Alfred
 26, 33, 44, 57, 65,
 82, 97, 122, *17, 80*
Munnings, Florence
 67

Naper, Charles 26, 36
Naper, Ella 26, 34, 36
Nash, Paul 102
New English Art Club
 18
Newlyn School 9, 17,
 24, 25, 26
Nicholson, Winifred
 96

Nijinsky 47
Nottingham Goose
 Fair 8, 37, 65

O'Gusts, the *59*
Orpen, Sir William 34

Pavlova, Anna 47, 52,
 35
Pearson, Corporal
 J. D. M. 101, *89*
Penzance Fair 37, *23*
Potter, Mary 96
Poynter, Sir Edward
 17
Procter, Dod 26, 64,
 76, 78, 124, *63*
Procter, Ernest 26

Quadro Flamenco 57

Randy (the clown) 68,
 56
Ravilious, Eric 76
Redpath, Anne 96,
 122
Richardson, Dr 118
Robbins, Corporal 101
Robertson, Rae 56–7

Scofield, Paul 118
Seago, Edward 65
Shaw, Dod *see*
 Procter, Dod
Shaw, George
 Bernard 89, 92, *76,
 82*

Sickert, Walter 18, 34,
 48
Simmonds, Herbert
 57
Simon, Lucien 57
Smeterlin, Jan 57
Smith, Granny 85, *77*
Snell, Dolly 34, *29*
Steer, Wilson 18
Stott, Edward 16, 18
Stuart and Sons 76
Sully, Mr 85
Sunderland, Scott 57
Swynnerton, Anne 64

Tennyson Jesse,
 Winifred 26
Thornton, Alfred 18
Togare (the lion
 tamer) 66, 76
Turner, Sergent D.
 101

Ulanova 118

Vanbrugh, Irene 89

Walke, Bernard 26
Walpole, Hugh 89
West, Great Aunt 8,
 9, 12
Whimsical Walker (the
 clown) 65
Wilkinson, A. J. 76
Worth, Miss 122